Natural Impressions

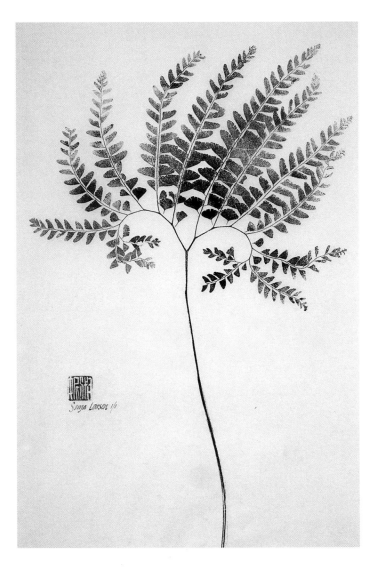

Natural Impressions

TAKING AN ARTISTIC PATH THROUGH NATURE

Carolyn A. Dahl

WATSON-GUPTILL PUBLICATIONS

NEW YORK

For R. Thomas Perry

NOTES ON THE ART
All works are by Carolyn A. Dahl unless otherwise noted.

PAGE 1: *Maidenhair Fern* by Sonja Larsen. Water-based inks on damp Sumi-e paper. 10 × 13 inches (25 × 33 cm).

PAGES 2–3: *Desert Energy* (detail). Watercolor, acrylic, leaf prints. 22 × 30 inches (56 × 76 cm).

PAGES 4, 20–21, 32–33, and 110: Nature prints selected from various works.

PAGES 6–7: *Freshwater Drum Scarf* (detail). Hand-dyed Thai Silks georgette, freshwater drum replica prints, ZIG textile markers. Maple leaf II stamp from Fred B. Mullett Co. 12 × 66 inches (30 × 168 cm).

PAGE 8: Prints from *Monarch Butterfly* by Vickie Schumacher. Oil-based block-printing ink on tea-stained printmaking paper. 6 × 9 inches (15 × 23 cm).

PAGES 10–11: *New York Nasturtiums* (detail). Metallic paints and appliqué on fabric. 22 × 22 inches (56 × 56 cm).

PAGES 60–61: Detail of a nature board (see page 72, right, for the entire piece). Daisies, leaves, gesso, and acrylic paint on mat board.

PAGES 90–91: *When Fish Fly* (detail). Origami butterflies on spray-dyed and woven paper. Big steelhead stamp from Fred B. Mullett Co. Diptych, each panel 19 × 33 inches (48 × 84 cm).

Copyright © 2002 by Carolyn A. Dahl
Unless otherwise credited, the photographs in this book were taken by Rick Wells or the artists.

First published in 2002 by
Watson-Guptill Publications,
a division of VNU Business Media, Inc.,
770 Broadway, New York, NY 10003
www.watsonguptill.com

Senior Editor: Joy Aquilino
Editor: Gabrielle Pecarsky
Designer: Areta Buk
Production Manager: Hector Campbell

Library of Congress Cataloging-in-Publication Data
Dahl, Carolyn A.
 Natural impressions : taking an artistic path through nature / Carolyn A. Dahl.
 p. cm.
 Includes bibliographical references and index.
 ISBN 0-8230-3149-7
 1. Nature prints—Technique. I. Title.
 NE1338 .D34 2002
 769'.434—dc21

2002003466

Printed in Malaysia

First printing, 2002

1 2 3 4 5 6 7 8 9 / 08 07 06 05 04 03 02

Disclaimer: The author and publisher have made every effort to ensure that all the instructions given in this book are accurate and safe, but they cannot accept liability, whether direct or consequential and however arising. If you are pregnant or have any known or suspected allergies, you may want to consult a doctor about possible adverse reactions before performing any procedures outlined in this book.

ACKNOWLEDGMENTS

I am grateful to the following people, who helped me bring this book into existence.

Joy Aquilino, senior acquisitions editor at Watson-Guptill, whose warmth and support allowed me to write the book I had in my heart.

Gabrielle Pecarsky, my editor, whose gentle and wise editing made the manuscript preparation a pleasurable experience.

Areta Buk for her artistry in transforming my words and photos into a beautiful book. My appreciation also goes to the many devoted and unseen hands of the Watson-Guptill production staff.

After long hours of working together in the studio, Rick Wells turned from photographer to friend. His craftsmanship, patience, and kindness will always be a large part of this book's spirit.

The artists who graciously lent their art, shared their stories, and increased my love of nature printing. I'm especially grateful to Sonja Larsen for her assistance in contacting members of the Nature Printing Society.

My writer friends—Lee Herrick, Faye Walker, Sandra Beckerman, Lane Devereux, Zoe Nonemaker, and Thomas Perry—for their valuable suggestions on my essays and their unending encouragement.

Betty Allen-Trembly, Lisa Selzman, and Kathryn Means for their willingness to listen to me think aloud as I searched for the form and direction of this book.

Marit Hatfield, a friend who knows that sometimes I need to be rescued from my creative cocoon. She balanced and recharged my energy many times by ringing my doorbell for coffee, interrupting my studio marathons, or slipping nature through my mailbox when I had to write but longed to be outside.

Irene Holmes, my mother, who passes to me the land wisdom she's gained from living in one place all her life.

All the gardeners who willingly opened their garden gates, allowing me to roam, write, or collect in their special spaces. Their leaves and flowers live on these pages. Special thanks to Susan Cooley and her peaceful City Garden, Zoe Nonemaker and her pear tree-filled Nonesuch, and Robin and Dick Brooks's Norwich Schoolhouse Garden, filled with flowers and birds during the day and the moon and stars at night.

If this book were a blossom, my husband, Thomas Perry, would be the roots that helped it grow. I will always be thankful for his constant support, computer assistance, coffee in homemade mugs, long morning talks, and patient understanding when words overtook me on a wooded path and I had to stop to write in silence. My expression of gratitude continues daily.

And finally, to nature, who constantly amazes, beautifies, and nourishes all our lives.

CONTENTS

Leaf Impressions

Flower Impressions

Fish Impressions

INVITATION

Come walk with me.

We'll talk of nature, art, and creativity. We'll visit my city garden,
slide down a country hill, talk to fish, and drink from the moon.

I'll open my nature journals, tell you stories, share impressions of
how nature can nurture your spirit, open creativity like spring seeds.

I'll teach you to fingerprint beauty, press painted leaves to cloth,
catch a flower's blush on paper, to see beyond surfaces to secrets.

So come, bring your artist's spirit, a gardener's loving hands, a child's
heart. Nature is near. She's waiting in the park, around the corner

on a path that leads us back
to our deepest selves.

Come walk with me.

INTRODUCTION: FINGERPRINTING NATURE'S BEAUTY

"I can't believe what my eyes missed," I said to myself as I lifted the leaf I had just painted and pressed to paper. It was my first nature print. I was surprised by the difference between what I had observed with my naked eye and what appeared in the print on the paper. I knew I'd see an interesting leaf shape with a prominent vein structure. But I hadn't expected the intricate lace pattern hidden in the green, the dent marks from a hailstorm, and a ragged hole where an insect had dined. The nature print was a new way of seeing the world. I was ready to fingerprint everything.

Even Leonardo da Vinci was fascinated by nature printing and left many prints in his fifteenth-century notebooks. Our artistic options and materials have grown since he held a leaf over a candle to coat the leaf's back side with carbon before pressing it to paper. Today, you can choose from a profusion of techniques and materials: metallic paints, heat-transfer crayons, bleach, adhesive webs, fabric paints, fish replicas, markers, stamps, photocopy machines, and computers.

Learning to nature print is more than making art. It's also about the power of nature to enlarge our creativity if we make a place for it in our lives. The beauty we see, the diversity of forms we touch, and the sense of reconnecting we experience, all have the potential to lead us to new artistic and personal insights. Whether you want to make a simple leaf print from your favorite backyard tree or a perfect botanical print of a flower, or use nature printing as a jumping-off point for creative experimentation, you're making contact with the world that sustains you.

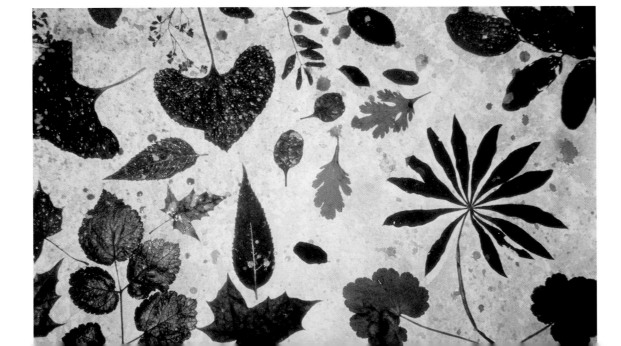

Fantasy Flowers (in progress) by Carolyn A. Dahl. 22 × 30 inches (56 × 76 cm).

Leaf

Impressions

Beginning the Journey

❧

I write through the moisture,
force the curling pages down.
My ink grabs the fibers of the paper,
refusing to gray out, but holds the color
like the dark pines of a Chinese painting.

Schoolhouse Garden (detail) by Carolyn A. Dahl.
Watercolor, acrylic, colored pencil, leaf prints.
22 × 30 inches (56 × 76 cm).

DISCOVERING YOUR CREATIVE PATH THROUGH NATURE

"You're a connoisseur of stones," my friend says, poring over the collection I've assembled inside a circle of leaves on her kitchen table. Against the wavy grain of the wood, each rock seems to float in a time-stopped creek.

"I've lived in this apartment for a year," she says, "but I've never taken the trails down the hill into the woods." I smile, but she doesn't look up.

The landscape felt like a spiritual home, a place I might have come from, if not my real home.

"These stones weren't chosen randomly. You saw something beyond the visual." She strokes a gray stone like a tiny animal that might speak, then looks up at me. "Could you teach me to be a connoisseur of rocks and leaves?"

The question surprises me. I'm honored she thinks her guest has some specialized knowledge, but I interact with nature in an instinctual, childlike, and variable way. I've never felt anyone needs to study a particular philosophy to enjoy nature, or to develop a plan. I've always believed that I'll receive what I need if I simply arrive and remain receptive. But I've never consciously watched myself in nature. If something in my personal approach could help my friend or others find their own paths through nature, then I needed to observe my process. That evening, sitting by an open window, I re-created the day's events in my journal, recording ideas to share with her the next morning.

With my friend at work, I had the day to myself. Although rain showers kept coming and going, I wanted to explore the woods that surrounded the apartment house. Borrowing a blue slicker, I stuffed a camera into a pocket. Heading toward the distant sound of a brook, I found a trail that zigzagged down the hill. Two huge, Buddha-like boulders sat side by side at the entrance. Their presence reminded me to pause, take a deep breath, and shift to a slower, more observant pace.

But the path oozed with slippery mud, sending me sliding down the hill. I quickly regretted my poor choice of shoes. Wet pine needles collected in the open toes, releasing a scent of turpentine as my weight slipped forward. Halfway down the hill, a sudden light change startled me. I flung my arm around a tree to stop my forward movement. Was the rain really colored as it dripped from the trees like dissolving stars? Pulling up my slicker sleeve, I raised my bare arm toward the light. I know the color of my skin so well that I can use it as a middle C from which to gauge all other color notes. Next to the unchanging color of my arm, I saw that the illusion was correct. The light, riding on raindrops to the ground, left color trails in the air like falling prisms.

Continuing my slide down the hill, I arrived at a spot near the brook. I sat in a rock chair and scraped my muddy shoes against a sharp edge. The water rolled past, massaging its sandy

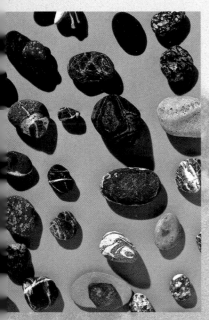

Each stone in my collection has a presence, a spirit that goes beyond visual beauty.

bed. I closed my eyes so I could hear it better. The water's pulse grew more insistent without the distraction of vision. It ran through my body like blood until it almost changed my heartbeat. I welcomed the rhythm, though, because the sound would lock the moment into my memory. Like a favorite song, I need recall only the sound to recall the whole day.

The rain continued to fall gently, misting my jeans and already-wet feet. I threw back my head and felt the moisture on my face. My closed eyes had heightened every body sense. I could hear an insect chewing nearby, smell mushrooms in the distance, and feel small streams of water make a detour around my nose. The landscape felt like a spiritual home, a place I might have come from, if not my real home.

Not every natural environment has been compatible with my body and spirit. Sometimes I've become restless, uncomfortable, and my inner spirit withers instead of expands. There's never been anything wrong with those landscapes—they just weren't in harmony with my body. Everyone needs different land features to feel a spiritual home.

The colors of the rocks were so intense that I wondered, "If I touch them, will the color come off on my hands?"

It was wonderful to sit in the rain uncovered. When did I begin to think of rain as a hostile element to avoid with an umbrella and hunched shoulders? It felt liberating to be as wet as the woods. The trees didn't mind my flat hair and the bugs crawled over my muddy shoes without criticism.

Opening my eyes, they snapped into sharp focus as if the alertness of my other senses had increased their potential. I scanned the area, watching what attracted my attention and what I ignored after a quick glance. What my eyes couldn't resist would be what nature wanted me to experience. Knowing that I favor ground-watching, I used an exercise borrowed from my ophthalmologist: During examinations, he directs me to look to the right, to my feet, to the left, and to the sky. Using this circular method in nature, I've often discovered beauty that my habitual observation pattern might have missed.

My eyes kept returning to the far left, where a patch of large rocks lay in a nest of leaves. A dense canopy of trees had shielded them from the rain and I couldn't believe their colors: turquoise gray, rusty buff, deep blue gray. Many of the rocks were water smooth, but others had bubbly surfaces like lava. I dug around the big rocks, searching for small rocks with the discrimination of a diamond dealer. One rock led me to the next, until, crawling on all fours, I had dug and sorted for an hour. I stood up stiffly, pockets bulging.

I don't believe in removing much from nature, and never anything large. I don't want to alter or destroy an area I've visited. Although I couldn't resist gathering the rocks on this day, I would do a second round of culling. I laid each one in front of me on a stump. How

exquisite the simple stones were. I studied their details, held them in my hand, as if weighing their desire to leave with me. I waited, hoping to absorb what I needed from their beauty without removing them. Although an aesthetic evaluation took place, it wasn't the sole factor in my choices. I didn't select a rock to use in an art project or as a souvenir. The rock had to have something deep in its spirit that matched a need within me. I relied on my body to sense the connection. If it signaled me with a rush of pleasure, a desire to laugh, or a feeling that I'd found something lost for years, I selected that stone. Even as I returned the chosen ones to my pocket, I knew that they, too, would eventually be returned to nature somewhere.

Being alone in the woods, I was free to explore. I felt energized and wanted to play, react imaginatively with nature, start the art process. As I followed the brook and climbed the hills, I stopped to make pinecone snakes slinking through leaves or hide acorns in folded fern packages in a hollow stump. I played with words, making up descriptive phrases in the Japanese tradition of bestowing special names on beloved elements in the landscape: Tree Loved by Lightning, Rock That Parts Fish, Trees That Would Be Flutes. The names brought back a day I spent in a burned-out forest in New Mexico, writing short poems on bare rocks with chunks of charcoal from the scorched trees. I've always wondered if anyone read them before the rain erased the words.

The afternoon passed quickly, but I had one more thing to do before I climbed back up the hill. I call it "second sight." I look once with my eyes, then look at the same scene or object a second time through the frame of another object: a camera, a pair of binoculars, a mirror, a microscope, a magnifier, or a small cardboard frame. The second look changes what I've seen and gives me a different perspective. I discovered the technique one day as I sat by my glass-topped coffee table: Upside down on its shining surface, I noticed my backyard as it came into the room through the windows. Seeing the familiar sky and trees shimmer in the glass like a mirage, I felt as if I'd never seen them before. Fascinated by what second sight added to my understanding of objects, I've made it a regular part of observing nature ever since.

I pulled out the camera, put it to my eye, and spent a few minutes just looking, without photographing. Then I laid on the ground for an unusual angle of the treetops and the under-belly of a black crow. Kneeling, I shot six frames that would link together to create one continuous view. A jagged leaf, covering half of the lens, gave a sharp edge to a close-up of another brightly colored leaf. For fun, I aimed the camera in the general direction of an object I wanted to photograph, but didn't use the viewfinder. I also bent over and shot through my legs, as I'd heard that if you want to see intense colors you should look at a scene bent over. Apparently, the blood rushing to your head heightens the color response of your retinas. I enjoyed the brilliant yellow of leaves stuck to an old log as I pushed the shoot button, but I knew the film would never catch the intensity I saw.

As I headed up the hill, the sun broke through the clouds. I lingered at the Buddha rocks, now a powerful rusty red. I carried some of their essence in my pocket.

GATHERING MATERIALS FOR NATURE PRINTS

Exploring your environment for nature-printing materials is always an adventure. In the country or a suburban area, visit your backyard, friends' gardens, the woods, and along roads. If you're an urban dweller, you don't have to leave the city or travel to collect materials to print. Sometimes it's not easy to see a five-foot (152-cm) tree next to a soaring, eighty-story skyscraper. But if you tune into the small things in your environment, you'll find patches of nature: potted trees scattering leaves at apartment entrances, high-flying window boxes dropping geranium petals, slender weeds surviving in an alley, even houseplants. Exotic flowers fill florist shops and markets overflow with fruits and vegetables, all waiting to be printed.

Collecting Equipment and Etiquette

If I'm collecting in the neighborhood and planning to return home within the hour, all I need is a large plastic bag to hold what I find. I always ask neighbors if I may collect in their yards, even though the person may never notice a few missing leaves. Requesting permission usually produces many interesting stories about this or that plant and the invitation to take as many leaves as you want. (As one of my neighbors enthusiastically exclaimed as she placed leaf after leaf into my hands, "They grow back like hair.") When someone or some institution, such as an arboretum, has been kind enough to allow me to collect on private property, I always send a thank-you note. Often I'll include several small prints of plants or leaves I've collected.

If I'm collecting during a long hike, I wear comfortable walking shoes, socks (to prevent insect bites), jeans (to protect my legs from scratches), a long-sleeved top with lots of pockets, a hat, and sunglasses. I carry a light-weight backpack to hold supplies such as scissors, plastic zipper bags, water, snacks, maps, sunscreen, insect repellent, a plant identification book (be sure you can identify any poisonous plants in the area), and a pen and small journal. My camera hangs from my neck so it's ready to use, leaving my hands free to collect.

Before placing plants, especially those with many leaves on one stem, into large plastic bags, I place them between pages of

I've never been able to pass a maple tree without bending to collect some of its hand-shaped leaves.

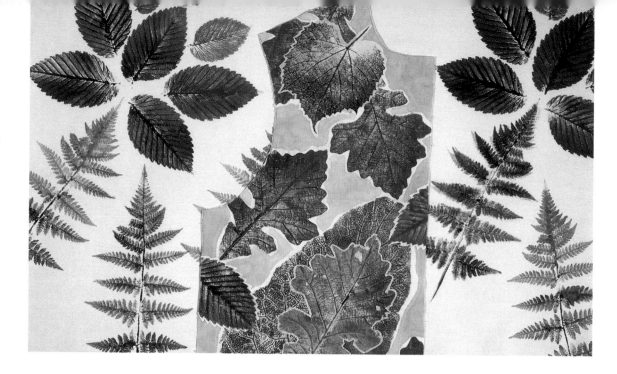

An assortment of good printing leaves. Feel free to experiment with any interesting leaf you find. Fabric paint on cotton by Carolyn A. Dahl.

a magazine to prevent curling. Then I insert the magazine into the plastic bag. This keeps the plants fresh and minimizes wilting. Once I'm home, I transfer them to old telephone books. Bark, twigs, mushrooms, pods, and other items I come across can be placed directly into a separate plastic bag and closed. Moisture retention isn't important, but isolating any bugs, ants, or critters that may have come along for the ride is crucial. Snail trails in a backpack aren't a pleasant experience.

Choosing Good Printing Leaves

Almost any object can be collected for a nature print, but let's start with leaves. They are one of the easiest subjects to print and are readily available. As I walk along, I look for fallen but still fresh leaves in a variety of sizes. I choose durable, flat ones as opposed to curled or rippled leaves, which will cause smearing or fold marks on the finished work. I prefer leaves with strong vein patterns, but

avoid thick, fleshy leaves, as the moisture will stain the paper or fabric when pressure is applied. Leaves that have an interesting outline (oak, maple), serrated edges (elm, paper birch), a dramatic shape (ginkgo, fig), or unusual size (elephant ears) make interesting prints. Don't overlook leaves with chewed edges, freeze damage, or insect holes. A leaf's history and life's markings are part of its beauty.

If I don't find leaves on the ground and I need to remove a leaf from a live tree or plant, I snip it off with a small pair of scissors. I'm careful not to twist or tear at the plant or rip back the bark, leaving areas where insects can enter. (I remember a friend saying that when her mother caught her mindlessly stripping leaves from a tree, she'd tug on my friend's hair and ask, "How does it feel?") I select my leaves from different areas of the plant and take only as many as I can print in one session (usually five to eight). If I've collected properly, no one will be able to detect my actions.

Printing as soon as possible after collecting is desirable, but not always possible. Leaves can be kept in their plastic bags in the refrigerator for at least three days, and strong leaves (ginkgo, oak, maple) can be frozen. If the leaves you've collected have dried out somewhat, sandwich them between sheets of damp newspaper and allow the leaves to sit for an hour (or overnight) before printing. If, however, they are too limp and wilted, press them in an old telephone book and print them as dried leaves.

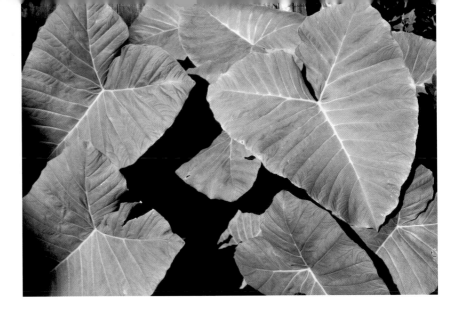

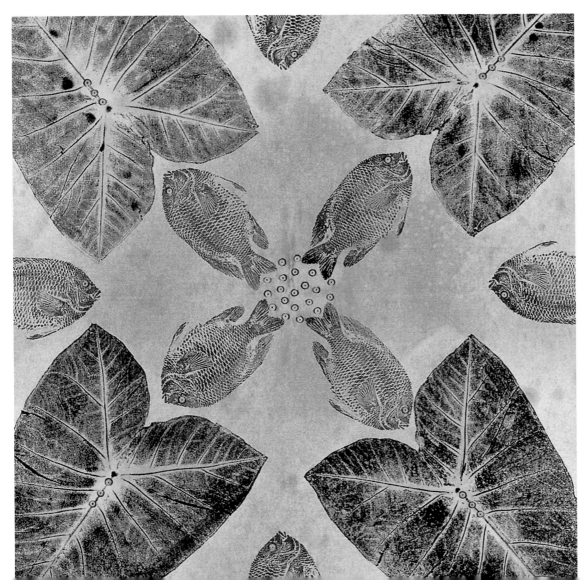

ABOVE: Elephant-ear leaves in my garden often grow to a length of twenty-eight inches (71 cm) and make large, heart-shaped prints.

LEFT: *Kaleidoscope Scarf* by Carolyn A. Dahl. Elephant-ear leaves printed with fabric paints on a hand-dyed Thai Silks georgette scarf. Big garibaldi fish stamp from Fred B. Mullett Co. 36 × 33 inches (91 × 84 cm).

SELECTING PAPER, CLOTH, AND PAINT

Although we've been discussing leaf printing, the following information on paper, cloth, and paint is intended for all nature-printing techniques in this book.

Paper

The best way to choose papers for nature prints is to visit your local art store and touch the papers that appeal to you. In general, you'll want a smooth-surfaced white or buff-colored paper that will catch all the subtle details of the subject. With leaf, flower, fruit, or plant printing, it doesn't matter if your paper is thick or thin, pliable or stiff. For fish printing, however, the paper needs to be flexible enough to drape around the body of the fish, but not so thin that it tears during the paint-transfer process.

For your beginning prints, start with whatever type of paper you have on hand: typing paper, drawing paper, newsprint, etc. Then progress to Sumi-e sketch paper (purchase sheets rather than rolls, which keep curling) and inexpensive printing papers. When you're ready, you can invest in more expensive papers (like those manu-factured by Rives or Arches, or etching, wood-block, and lithograph papers) and traditional Japanese papers (such as Hosho, Mulberry, or Unryu; Hosho comes in a student grade, which is less expensive than its professional grade). Tableau is another

choice. It is a domestic paper, but it has very long, imported vegetable fibers that make it equally strong, wet or dry.

Most papers are dampened before printing by spraying a light mist of water above them and then sandwiching them between plastic sheets to allow the moisture to penetrate the fibers evenly. Always err on the side of less rather than too much water—otherwise, water-based inks may bleed and oil-based ones could be repelled by the water. I often dampen papers with a quick wipe from a damp sponge because my sprayer gives an uneven spray. I've also printed on dry paper by increasing the fluidity of my paint. Making a few test prints will help you balance the moisture of the paper, the subject, and the paint.

You can also make prints on unusual materials, such as LUTRADUR (a spun-bond, nonwoven fabric), which resembles the white interfacing sold in fabric stores. Tyvek is another interesting material (a white, nonwoven, nonpaper sheet), most easily recognized as the soft, thin white mailing envelopes used by the post office and overnight delivery services.

Cloth

Nature prints can be made on fabric for framable artwork, home-decor items, or wearables. (If you don't like to sew, ready-

to-print white clothing blanks are available from Dharma Trading Co.; see page 111.)

Like paper, select fabrics with a smooth surface to catch fine details. Any fiber content will take fabric paints (unlike dyes, which are fiber specific): polyester-cotton blends, cotton, synthetics, rayon, and lustrous silk. China silk (or Habotai) is a lightweight, smoothly woven silk (order the eight- or ten-momme weight) that yields a beautiful print. All fabric should be washed to remove sizing—which can block paint absorption—and then ironed to flatten the fibers for printing.

White fabric yields the strongest contrast when printing with dark ink, but white paint on a dark colored fabric is interesting, too. Experiment with printing on patterned, hand-painted, and marbleized backgrounds.

Paints, Inks, and Tools

Many types of water-based or oil-based paints or inks can be used to make nature prints on paper. Water-based paints dry quickly and are easily cleaned up with water, but they can bleed if your paper is too wet. Oil-based paints take longer to dry, giving you time to blend or layer many colors, and they don't bleed on dampened paper, allowing you more control. They also don't reactivate with water, so solvents are required for cleanup. However, Turpenoid, an odorless turpentine substitute, has made that process less unpleasant.

For printing on paper, I like Speedball Water-Soluble Block Printing Ink or Speedball Oil-Based Block Printing Ink, both of which come in a variety of colors. I have also used acrylic paints and lithographic and etching inks. If you're a beginner, start with water-based ink or paint.

For fabric, I use water-based fabric paints (suppliers also call them textile pigments or inks) because they have special binders that leave the cloth soft and washable after the fabric has been heat-set. I seldom need to dilute the paint, except for maybe a spritz of water, as its creamy consistency is usually perfect. Diluting with water breaks down the binder, which may affect the paint's adhesion during washing. Most fabric paints are semitransparent, so if I'm printing on dark fabric I purchase opaque fabric paint.

Printing in black on paper or fabric and then adding color after the print has dried can create very realistic-looking nature prints. Of course, you can combine your paint colors, mix them directly on your subject, use metallic paints for emphasis, or add glitter to the still-wet print to mimic the sparkle of light.

Brushes and applicators are your tools of choice. You can use bristle brushes (except with fragile fresh flowers, which can be damaged), craft-foam rollers, foam applicators, and tampos (silk fabric gathered around a cotton ball; see page 101). With very large subjects, such as elephant-ear leaves or a large fish, rollers work best because you can quickly cover the surface before the paint dries out. A fan brush (such as Winsor & Newton sizes 2 and 4) can be used to smooth the surface and add touches of color.

Inking the Leaf: Nature Printing

Although leaves will be used, this demonstration presents the basic nature-printing method used for all plant materials.

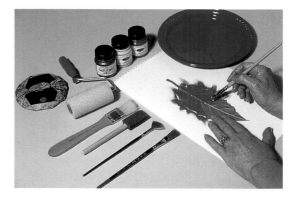

1 Lay a leaf on scrap paper and apply paint in one color or multiple colors to the underside until it is covered. Smooth out the stroke lines and any excess paint collecting around the veins. (Paint should be a creamy consistency; dilute it with a spray of water until it reaches the desired consistency.)

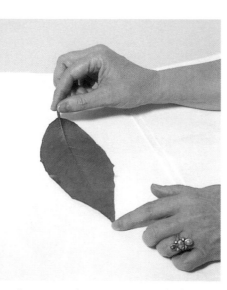

2 With your fingers or with tweezers, grasp the leaf at its stem. Place the painted leaf face down on the paper or fabric. (You can also try painting both sides of the leaf and laying it between a folded sheet of paper to yield two prints.)

3 Cover the leaf with tissue paper. Hold the leaf in place with one hand, and with the other begin rubbing with your fingers from the center to the edges of the leaf. The way you rub (pressure, speed, circular or irregular pattern) becomes like a brushstroke, indicating your mood. Take your time and enjoy the leaf under your fingers. Be sure to rub the edges of the leaf and avoid returning to an already rubbed area. A printer's baren or a hard roller may be used instead of your fingers.

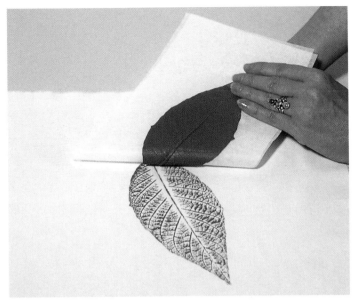

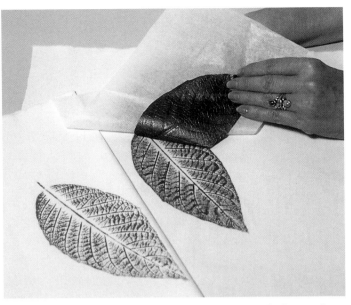

4 Remove the tissue paper and the leaf with your fingers (or tweezers). Discard the soiled tissue paper.

5 If you want to make two-color prints, print the same leaf in another color over the first print.

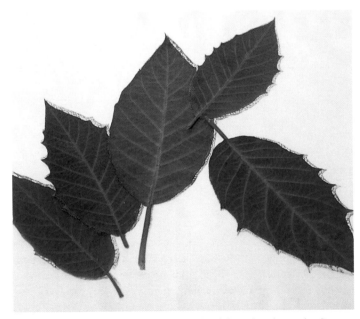

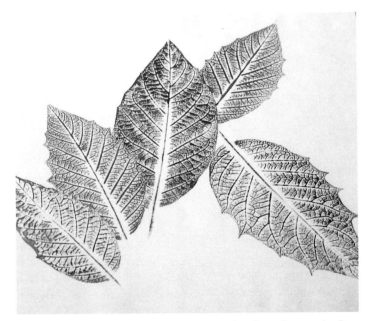

6 To create a sense that one leaf is behind the other, leave the first leaf in place as a mask and print the next one, overlapping the edges of the first. When rubbing, try to avoid the first print. Continue in this manner until you have used the number of leaves desired.

7 When finished, remove all the leaves. Don't wait too long or the first ones will stick to the paper or fabric. (Do not throw away your painted leaves, as they can be glued to cards and boxes, or added to artwork. Before doing so, first apply a heavy coat of acrylic medium.)

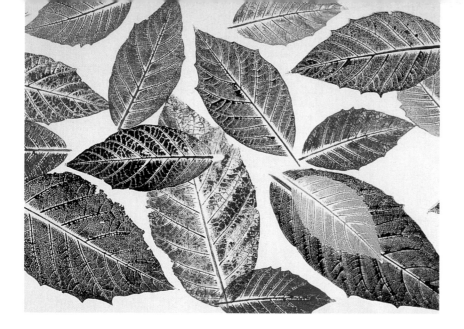

Final Steps

Allow the prints to dry. Correct any line gaps with markers in a similar color or with a very fine brush. Always make a few extra prints on another piece of fabric or paper; these can be fused over the mistake. If printing on fabric, follow the paint manufacturer's instructions for heat-setting the paint to ensure that the paint will be permanent and washable.

Color can be added to the white spaces within the leaf print after the print has dried. Use colored pencils, acrylics, or watercolors on paper and textile markers or paints on fabric.

ABOVE: Two-color printing and blending multiple colors on one leaf yield prints with richer colors and more dimension.

RIGHT: Clustering and overlapping leaves can create new compositions. These leaves were printed with a dark green color on cloth and enhanced with ZIG textile markers.

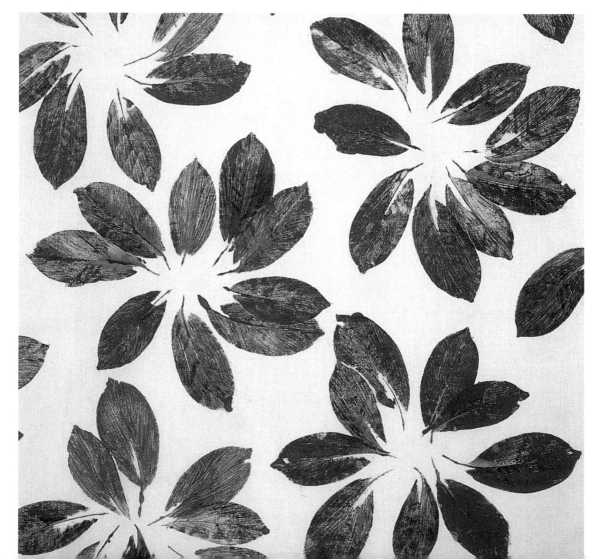

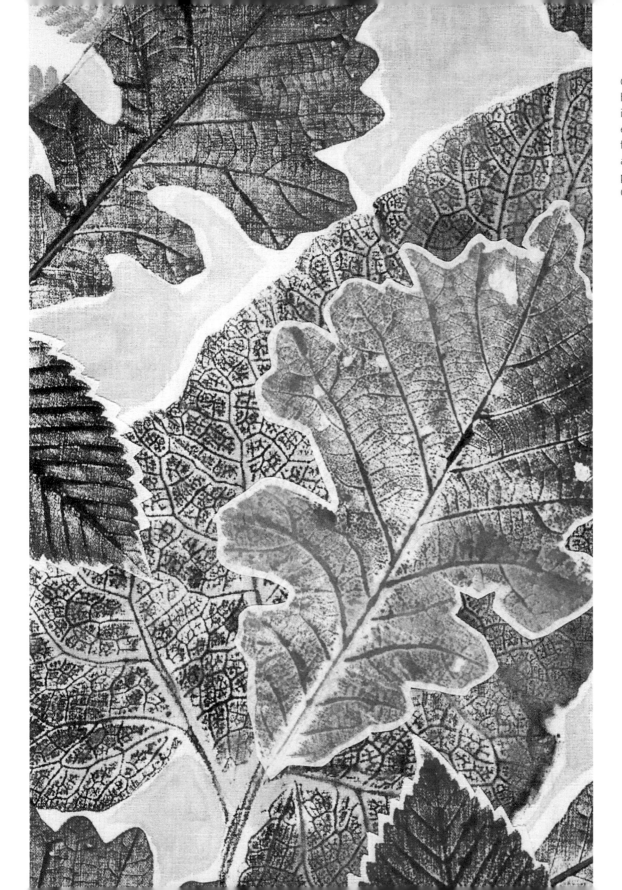

Good printing leaves have strong veins and interesting outlines or edges, should be fairly fresh, and come in a variety of sizes. Fabric paint on cotton by Carolyn A. Dahl.

DECIDING ON YOUR COMPOSITION STYLE

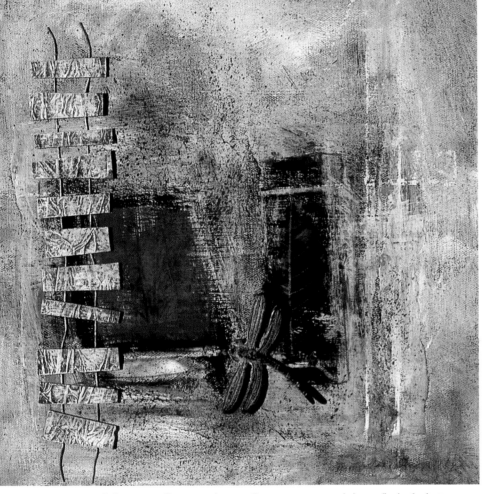

Dragonfly by Ann Bellinger Hartley. Acrylic on canvas, metal dragonfly, leaf, photo transfer. 14 × 14 inches (36 × 36 cm).

Just as there are many different styles in art, there are many different ways to approach nature printing. Nature sets some parameters because we're printing with actual objects, but our compositions can still reflect our personalities. Let's say, for example, you've collected a variety of leaves on your walk and now must decide on a format.

If you love the elegance of botanical prints (opposite, right), nothing brings out details as much as the one-color method. Printing in black, or another dark color, on a white surface creates a print of high contrast that emphasizes every element in the leaf or plant's structure. Without the distraction of color or background patterns, all our attention focuses on nature's simple, exquisite design.

If you prefer, however, that the leaf prints be an important element in your artwork, but not the only subject, repeating the leaf's shape gives it emphasis but not dominance. And if you have a sense of humor, or like to imagine shapes from familiar objects (leaves as butterfly wings), your nature prints will have a slightly surreal quality. Letting the leaf almost disappear into the work creates a softer focus and a more painterly composition. Sometimes a nature print becomes a catalyst for a new direction or redefines what a nature print is.

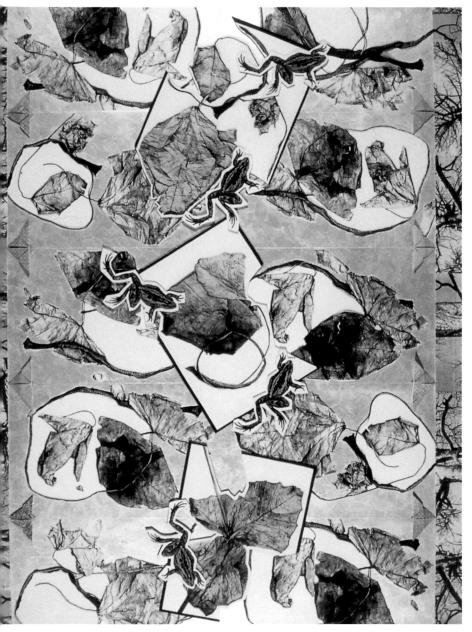

Canopy by Carolyn A. Dahl. Acrylic, photocopied leaf prints, origami butterflies. 32 × 40 inches (81 × 102 cm). Photograph by Maria Davila.

Signing with a Seal

Many nature printers use seals as a design component in their works or as part of their signature. Chinese office-supply stores can carve a personal seal for you (from soapstone) in Chinese characters in either the relief style (red lines on a white background) or intaglio (white lines on red background). Artists often choose to use their birth names, artistic names, short poems or sayings, or whatever comes to mind.

You can also purchase rubber-stamp seals and use pigmented ink instead of the oil-based vermilion (made from a poisonous mercury compound, so apply it carefully) typically used for carved seals.

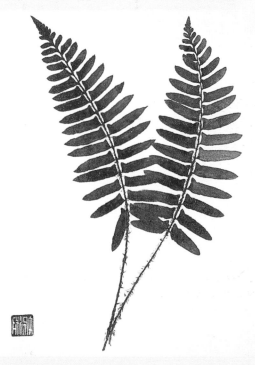

Two Ferns by Sonja Larsen. Oil-based inks on lightweight watercolor paper. 10 1/2 × 13 1/2 inches (27 × 34 cm).

27

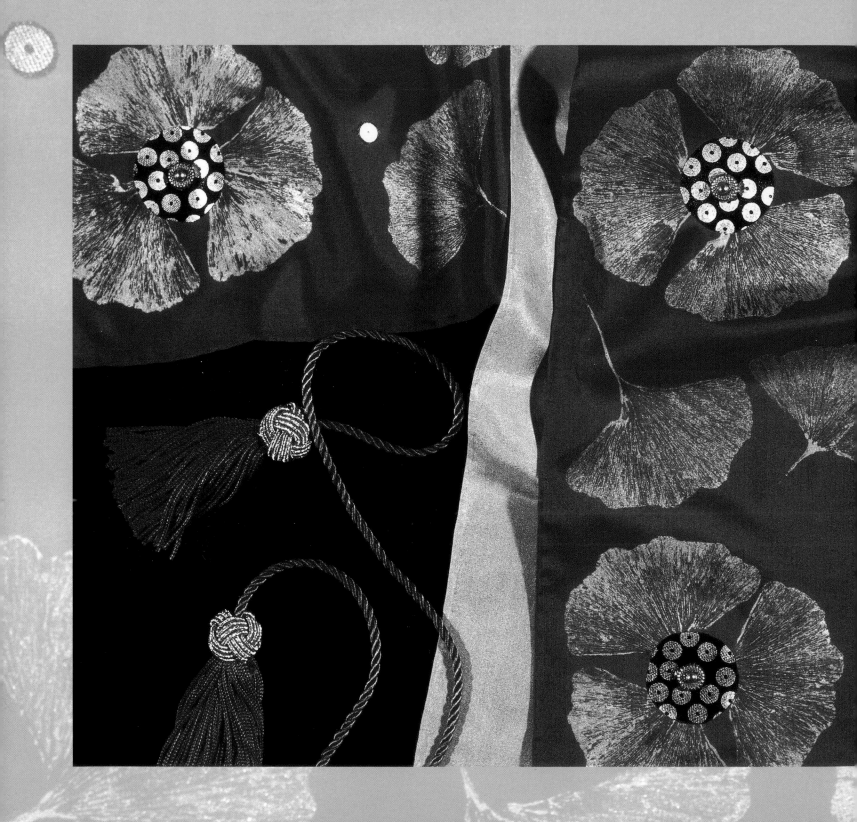

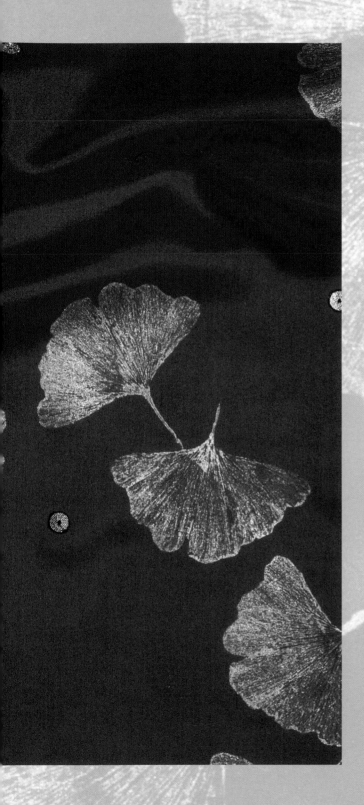

Catching Nature's Colors in Your Memory

🍁

My grandmother's garden was her farm,
acres of tall tasseled corn, bee-covered
clover, and potato plants growing white
underground fruit in the rich black soil.
But her heart lived in a patch of poppies
unfolding their crinkled red petals, thin and
brilliant as tissue paper someone set on fire.

Ginkgo Gold (detail) by Carolyn A. Dahl. 11 × 57 inches (28 × 145 cm).
Lumiere® metallic gold paint on Thai Silks Habotai scarf.

MORNING GLORY ON MY PILLOW

Often during nature walks, I discover leaves, flowers, or tree bark with intense, unusual colors that I want to remember. But holding color in my mind is like holding a cloud in my hand. I've tried many different color notation systems: watercolor swatches in my journal, colored pencil scribbles on index cards, meditation and color-visualization techniques, commercial color cards, and, in desperation, six packets of decorator paint chips that left me totally confused. Every time I thought I had captured elusive colors, I couldn't reproduce them in my studio. They came close to what I had seen in nature, but the spirit, the life, and the excitement had disappeared.

I had given up on all systems when I received a notice that one of my paintings had been selected for an exhibition at the New Orleans Museum of Art. A friend and I decided to attend the opening and stay with her mother in her graciously aging Victorian home.

The opening was exciting and lavish, with several after-hours parties. When I finally climbed the steep stairs to my bedroom, my brain buzzed with art talk and painted images. The lights were dim in the room, like tiny glow-in-the-dark planets pasted to the high ceiling. I dropped into the bed below a tall window that was slightly open, allowing a thin stream of humid air to slip through the shutter slats.

I awoke slowly, the way you should in the South. A strip of sun coming through a shutter slat streaked across my closed eyelids. When I reluctantly opened my eyes, I thought I hadn't. I saw nothing but quivering blue, as if the Big Dipper had poured the sky into my pupils during the night.

Still unsure whether I was awake or asleep, I reached out for the blue expanse and touched the soft skin of a flower. In front of my face, practically curled around my nose, bloomed the bluest morning glory I had ever seen. During the night, a vine had stopped climbing the side of the house, detoured from its quest for the sky, and slipped a stem through the open window. Wrapping several tendrils around a shutter slat for support, it had pushed its heart-shaped leaves toward my bed, dangling one waiting blue bud right over my eyes as the first vision of my day.

Nature had come to look at me. I had never had a plant make a definite physical movement toward me. Had it wanted to investigate me? Did it find me a colorless creature compared to nature's vivid hues? Perhaps I called it with desire. Morning glories are my favorite flowers and my greatest gardening disaster. Every year I plant them, every year they fail, and every year I beg a few blooms to sneak into my yard from my neighbor's overflowing vines. I dream of having morning coffee with morning glories, while I read haiku poetry inspired by their beauty. I'll stop my car anywhere I see an abandoned shed covered in heart-shaped leaves and

> *Nature had come to look at me. I had never had a plant make a definite physical movement toward me. . . . Did it find me a colorless creature compared to nature's vivid hues?*

collect wild seeds that might be stronger than the packaged varieties. But most of my morning glories grow in my books and behind the frames of my Japanese woodcuts. I'd come to think of them as an unattainable flower, until this day.

I couldn't stop looking at this blue glory resting on my nose, letting me stare into its pale throat. For the first time, I understood what the seed package had promised: "Heavenly Blue." If I had been in my own home, I would have stayed with the flower all day. But the smell of breakfast coffee wafting up the narrow steps reminded me I had to hurry to catch a flight home. I had been given a gift of beauty, if only for a few minutes. Holding the tubular flower in my cupped hand, I kissed it. The thin membrane of the flower stuck to my lips as if it acknowledged our communication.

Supporting the flower with one hand, I gently unwound the tendrils from the shutter with the other hand. I slipped the stem's tip through the open window, hoping it would seek the outside light again. But I left the flower on the window ledge, half in the room and half out. Closing the shutters gently, I hid its presence from the owner's eye and weeding hand, leaving our secret to its one-day bloom.

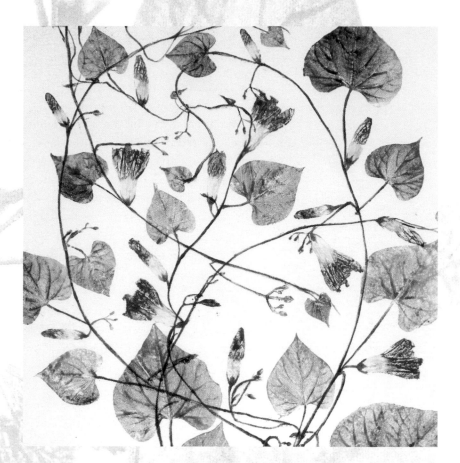

Morning Glories by Vickie Schumacher. Fabric paint on cotton.

Later on the plane, writing in my journal, I realized that the morning glory had brought me not only beauty, but also an insight: if I wanted to remember nature's colors, I needed to remember the details of the color experience and why it was emotionally important to me, then move on to the color. Other color notation methods hadn't worked because I focused only on remembering art-class definitions of color: hue, value, intensity. What I needed to preserve was the mystery, the awe, the thrill of the encounter. If I could recall that moment, it would become the art, and bring the color along with the memory.

Even though images are my main vocabulary as an artist, I found that words could "catch" color more accurately in the moment and unlock my memory banks faster when I needed the information later. I didn't have to compose an organized, grammatical, crafted piece of writing for color-catching to work, but simply a collection of jottings, half-finished thoughts, word images, lists, sentence fragments. I'd simply collect on paper whatever fell out of my mind.

USING THE "COLOR-CATCHER" METHOD

If you'd like to try my color-catching technique, the following questions will help you begin the writing process.

1. *What objects, sounds, and smells will be forever associated with this color experience?*
Recalling the environment in which the object of nature was first viewed helps us to understand how ambient colors may have affected its vibrancy, or how our emotions may have influenced our response to the color.
EXAMPLE: "I will always remember the faded yellow wallpaper in the room, the pink sheets turning the morning light rosy and dreamy, the flickering leaves moving outside the window, a New Orleans cable car rumbling in the distance, the smell of humidity in the high-ceilinged room, the pattern of my dress slung over the faded needlepoint chair like a collapsed person, the smell of strong coffee infiltrating my room like a fragrant alarm clock."

2. *What object do you own that is similar to the color you want to remember, and how does the object differ from the color?*
Relating a color in nature to something already in your life places it in a general color range. This gives you a starting point, or baseline color, from which to begin mixing your paints. Describing in words how the two colors differ takes you to the next step: modifying your initial mixture. You may not achieve the exact color you saw in nature, but your result will have the emotional excitement you first felt.
EXAMPLE: "The morning glory's color was similar to the silk turtleneck sweater I received last Christmas. The flower's color, however, leaned toward the blue-purple of the azure pansies I grow, although it was considerably darker."

3. *Besides the dominant color (blue, red, yellow, etc.), what else do you notice about the color?*
A blue blob of paint in a white dish remains an inert shade of blue. But a morning glory bobbing on a stem changes its colors and characteristics. Searching for words to describe what you see develops your color-differentiation skills and forces you to closely observe nature. If you catch the details, you'll catch your emotional response.
EXAMPLE: "The throat of the morning glory was a creamy white that changed to a faint yellow, making the blue trumpet shape more brilliant by contrast. The flower's color looked moist, as if it were dew-covered or freshly painted. The blue was translucent, thin, and fragile, like blue skin or delicate Japanese paper. When I touched it, I thought I would tear or bruise the surface. The slightly opaque veins reminded me of threads."

4. *What is your emotional response to this color?*
After you've mixed a baseline color and modified it slightly, return to your notes to recall your original feelings while in the presence of the color (calm, agitated, peaceful, excited, joyous). Ask yourself, What color would that emotion be? Whatever your answer, add a tiny touch of that color to your mixture, even if it seems totally wrong. The unexpected, perhaps offbeat, addition creates the emotional edge your baseline color needs.

EXAMPLE: "At first, hardly awake, I was confused by the color before me. Was I dreaming? Then I thought something had gone wrong with one of my eyes because all I saw was blue: Had the sky fallen over me? Was I suddenly seeing the blue of my own iris? Initially, I couldn't make out the overall shape of the flower because it was too close and, additionally, I didn't expect to find a morning glory inside a house. After I realized what had happened, I laughed and felt happy, charmed by nature's surprise. In a way, a dream had come true. Facing Georgia O'Keeffe's flower paintings, I've always wanted to fall inside one. On this occasion, I felt that I had done just that. I was overwhelmed with tenderness for the fragile, quirky flower that had ventured beyond its boundaries."

5. *In a few words, how would you summarize the color experience?*
Think of your summary as a title for an artwork. Look at what you've already written and underline evocative or powerful phrases. Condensing the experience into key memory words or phrases provides a means to call up the moment and the color—and a great way to catch images on the run.

When you walk in nature with others or take a tour, you may not have time to write down lengthy answers to all the questions in the color-catcher method. For those times, I focus on catching the key images. Carrying a small pocket journal as I walk, I jot down individual words or short phrases. Sometimes a whole page consists of only four scribbled words, but these same four words contain what I need: what I saw and what it made me think or feel. Like a haiku poem, a large amount of nature's inspiration and information can be carried by a few memory words.

EXAMPLE: "The skin of the sky, glory on my nose, blue of my own iris, throat of the morning, blue skin, eye to eye, New Orleans trumpets."

CREATING MEMORY-INSPIRED LEAF PRINTS

All the artwork that follows was inspired by journal entries made as I used the color-catcher method. Sometimes, the words produced immediate images, but often the sentences tumbled in the back room of my mind for months. Then they'd suddenly roll into view again and push me toward an idea I hadn't expected. I've learned that when I cast my net for colors, I can never predict what I'll catch in the memory words.

Fantasy Flowers by Carolyn A. Dahl. 22 × 30 inches (56 × 76 cm).

JOURNAL ENTRY
"Pushed under the water by a driving rain, spotted leaves lay on the pond's bottom, an oriental carpet for fish."

TECHNIQUE
Diluted pink watercolor was sprayed on white paper and allowed to dry. Leaves were laid on the paper as masks and other colors were sprayed around them. The leaves were left in place until the paint was dry. The fantasy flowers (graphite and pastel) were collaged over the background.

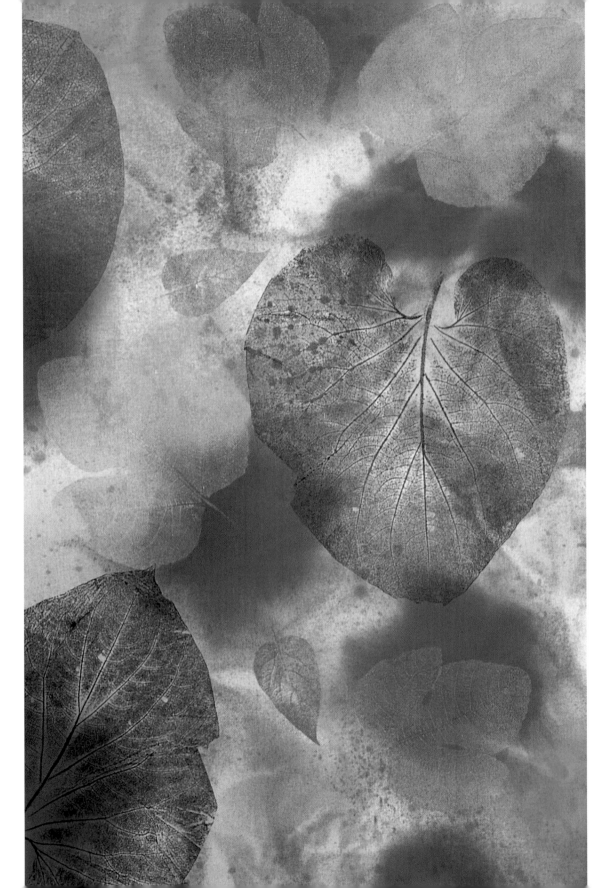

Leaf Pond by Carolyn A. Dahl. 54 × 56 inches (137 × 142 cm).

JOURNAL ENTRY
"Walking over a small bridge, I see large leaves floating on the water like silk handkerchiefs dropped from clouds."

TECHNIQUE
The cotton fabric was sprayed with fiber-reactive dyes (when using these, always wear a respirator and spray outside in a location that is not windy). The fabric was heat-set, washed, and overprinted with large leaves using fabric paint.

Dreamtime by Carolyn A. Dahl. Poison dart frog stamp from Rubber Stampede. 36 × 33 inches (91 × 84 cm).

JOURNAL ENTRY
"After the Aboriginal art exhibit, all of nature is alive with dots."

TECHNIQUE
A Thai Silks georgette scarf was stamped, stenciled, and leaf-printed with fabric paint.

HINT

Test your printing colors on scrap fabric or paper to determine whether the color will stand out from a patterned or colored background. Generally, you'll be more successful if you print dark colors over light backgrounds and white or opaque colors over dark backgrounds, or if you use leaves that yield a dense print. Metallic and glitter paints, which reflect light, will also draw attention to the leaf print on a busy background.

Eve Had a Better Design by Carolyn A. Dahl. Hawaiian petroglyph figure stamp and African art lizard stamp from Pelle's See Thru Stamps. 32 × 40 inches (81 × 102 cm).

JOURNAL ENTRY
"If Eve had seen my dress-size elephant-ear plants, she would have objected to wearing a skimpy fig leaf."

TECHNIQUE
Acrylic-painted elephant-ear leaves were printed on tea-dyed silk organza. The organza leaf prints were cut out and pinned to a woman's and a man's swimsuit pattern and collaged onto a block-printed, stamped, and painted-paper background.

Ice Crystal Morning by Carolyn A. Dahl. 20 × 29 inches (51 × 74 cm).

JOURNAL ENTRY
"Early ice storm. Grape leaves—fragile as frozen black butterflies."

TECHNIQUE
Cotton fabric was scrunched, diluted fabric paint was poured into the folds, and the fabric was allowed to dry in that position. After ironing the fabric, a grape-leaf vine was printed over the ice crystal design. Origami butterflies represent the butterflies that died in the early freeze.

Illuminating Your Nighttime Mind

Snow is not sun, said the poet Paz.
No, she said, it is the moon.
When it snows, the moon is falling.
That's why children make snowballs,
to throw the moon at their friends.

Treescape (detail) by Carolyn A. Dahl.
See page 48 for the entire piece.

DRINKING THE MOON

I'm sitting in an icy lawn chair, surrounded by snowdrifts, watching the full moon rise like a huge sequin. Although I could have chosen a more hospitable season for moon viewing, my favorite time is a cold winter night. Nothing brings out the beauty of celestial nature like branches pointing in the sky, dried leftover leaves, and piles of snow hushing the landscape.

I settle into darkness, tuck my wool scarf tighter around my neck, and tilt my head back, centering the moon in my sight. It's blissfully quiet out here. Everyone is asleep in the house. Even the pine trees are whispering. I've missed the moon, with its shimmering light. Lately, I hurry through night to events, but seldom stop to experience the beauty of the celestial bodies pulsating, spinning, and shining above me. I wonder why they don't catch my attention more often. Instead, I pull the shades down at night and obliterate the moon with artificial light. Only moon viewing brings me back.

Moonlight is like a psychic bump in the night, shaking up my perceptions of reality so a door to imagination can swing open.

Moonlight feels strange on my face. Is it because it is secondhand light gathered from the sun by an ashen moon, to be dropped on earth like fine, luminescent face powder? Maybe it entrances me because it's not of this earth and I have nothing with which to compare it. Moonlight comes from outer space, a vast area of unexplored nature that I'll never touch. The light is mystical. Everything around me seems to quiver as if someone were rocking a large mirror in the sky. Even the solid, clearly defined shapes I know so well during the day blur into vague shadows. Moonlight is like a psychic bump in the night, shaking up my perceptions of reality so a door to imagination can swing open.

Like most children, I used to believe a man lived in the moon. I pull binoculars from my nearby supply basket and search the moon for that face. It's hard to imagine his features now that an actual man has left footprints on its surface. I focus the lens for a better look. Magnified, the pocked moon advances toward me. It seems close enough to pluck like a loose button. The closeness disorients me, confuses my sense of place. Maybe I've left the backyard and am floating in space in my lawn chair. Maybe the huge eye of the moon is watching me.

I lower the binoculars. People used to believe you'd become a raving lunatic (*luna* means moon, *tic* means struck) if you stared too long at the full moon. I don't want to go crazy, but I wouldn't mind if my creative self were "struck by the moon" every so often. I sometimes need to be pleasantly strange to break out of the box that comprises my habits. I've noticed that when I stay up late, disrupting my sleep pattern with moon viewing, I often have more unusual, original thoughts. It's not that I'm more clever, it's just that the moon becomes a late-night muse that puts my logical daytime mind to sleep so my dreamlike nighttime mind can sneak out.

When a band of clouds obscures the moon, I rest my eyes and search my basket for an apple. The Japanese created special dumplings, custom-designed rooms, and commemorative

haiku for moon-viewing celebrations. The apple is part of my own ritual. I pack food that mimics the shape of the moon: pale golden apples, crescent-shaped almond cookies dusted with sugar, and creamy white-chocolate candy. I also have three dimes in my pocket that I shook when I first saw the moon tonight and made my moon wish. (According to folklore, people used to believe the moon was made of silver, so holding coins increased one's chance for a successful wish.)

Back in my chair, a sharp wind slaps my face with stinging snow. It's almost midnight and getting colder. I pour some hot tea from my thermos into a thick pottery mug. With gloved hands wrapped around the mug for warmth, the jasmine-scented steam rushes over my cheeks and rises into the cold air in tiny clouds. The moon is directly overhead now, looking like a pristine disk of blank watercolor paper.

Artists need visually vacant areas in their lives. I crave spaces devoid of advertising debris, or the insistent throb of others' ideas, or even the clutter of my own unfinished images. Whenever I'm blocked in my artwork and nothing else helps, I take down all the work on my studio walls—and sometimes even the paintings in my house—then sit with nothingness until something arrives. I've learned that if there's no blankness before my eyes, there's no space for my own creativity to appear.

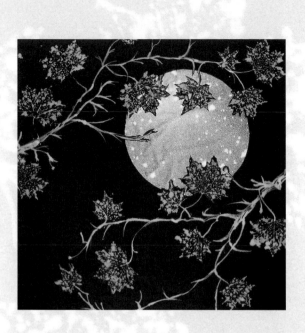

Moonscape by Carolyn A. Dahl. Bleached cotton fabric. 41 × 43 inches (104 × 109 cm).

A shooting star streaks to the left of the moon. Quickly, I make a wish during the transfer of souls—one soul is leaving heaven for earth, another leaving earth for heaven. The blazing star makes me think of all the artists through the centuries who have been inspired by the moon. Suddenly, I laugh at my own "moonstruck" insight: It's the same moon! I can't believe that all these years, unconsciously, I've believed that the moons that artists have painted belonged to their own centuries, like period furniture or clothing styles. But every generation from the beginning of time has seen the same moon I'm enjoying tonight.

I try to catch the moon's reflection in the tea mug as if it were the palm of my hand. When I have the little circle floating on the green tea, I recall the story about a famous Chinese tea master noted for his incredibly delicious tea. When someone asked for his brewing secret, he simply replied that he always collected his water from a clear mountain stream during a full moon. He'd dip into the reflective surface and carefully carry the water home, guided by moonlight. He believed the reason his tea tasted special was because he "cooked the moon."

After drinking down the moon, I let my thoughts bounce around the sky for another half hour. The night is quite bright now. The snow crystals around my chair reflect the moonlight, amplifying its intensity until I feel like I'm sitting in fireflies. The glow makes me sleepy, and, since it's bad luck to sleep under the moon, the time has come to go inside. But I'm reluctant to leave the moon alone all night, unadmired, so I walk to an untouched expanse of snow and fall backwards. Waving my arms and legs I leave a snow angel for company.

MOONLIGHT IN A BOTTLE: BLEACH AND THINGS TO KNOW

Try moon viewing for yourself. You have twelve opportunities per year. Devise your own meaningful ritual and keep a pen and paper nearby to catch any wild thoughts that drop from the sky. Then put your ideas to work with bleaching (also called discharging). It's a perfect art technique to try after moon-viewing, as the resultant light and dark images look like they're bathed in moonlight.

When household chlorine bleach contacts black fabric (or black paper; see page 49), it breaks the existing chemical bonds of the color, changing it to a lighter shade. Usually a beautiful gray, beige, or off-white emerges from the black, but sometimes a surprising gold or reddish tone results. The variation depends on the dye mixture used to make the original black. Half of the excitement is never knowing what color will appear.

Chlorine bleach works best on 100-percent-cotton fibers. Do not bleach silk or synthetics with chlorine bleach, as it will damage the cloth. Black fabrics with a smooth weave produce the clearest details and highest value contrast, but other dark colors, such as burgundy red, forest green, navy, deep purple, and brown, can also be used.

All fabrics will not discharge with the same amount of bleach. Some—especially expensive fabrics—may be very resistant to color removal and require a higher concentration of bleach. Purchase a small amount of sample fabrics and conduct tests before buying large quantities. Mix about a cup of solution, consisting of one part bleach to one part water, and brush it onto a corner of your test fabric. Wait a few minutes to allow the bleach to work. If the color doesn't change, increase the amount of bleach a little and test it again. Try to use the least amount of bleach possible to achieve your results. If the color on a fabric doesn't change, discard that sample.

Bleach can be applied to the fabric by stamping, brushing, dipping, stenciling, dripping, pouring, or spraying (spray outside, and protect nearby objects, as the spray drifts). Use only small cuts of fabric (one to one and a half yards [91 to 137 cm]) for stamping and stenciling if you want a consistent color: Areas that receive the bleach first

To make bleached leaf prints, dip the leaf in bleach and allow the excess to run off. Lay the leaf on fabric, cover with scrap paper, and rub or press.

will become much lighter than those that receive the bleach later. Use only inexpensive or old brushes for bleach, as it can damage the bristles.

Like many household cleaners, bleach should be used carefully. I recommend wearing eye goggles (in case of splashes), a respirator, household rubber gloves, and old clothes (to protect your skin, especially when spraying bleach). Always work outside, in a garage, or in a room with good ventilation. Never dilute the bleach with anything except water, and always cap the container immediately after pouring out the amount you need into a glass container (bleach can react with metals and eat through some plastics). Keep bleach out of the reach of children and pets.

When the bleached areas become the desired color, the fabric must be neutralized to stop the bleach's action. Use either a solution of vinegar and water (three parts vinegar to one part water) or a professional neutralizer, such as Anti-Chlor (see Source Directory on page 111). Leave the fabric in the neutralizer for at least five minutes. (I have left it up to a half hour.) Rinse the fabric in water to remove the neutralizer and machine wash it. Before discarding the solution, I neutralize all brushes, stamps, and applicators used during the creation of the work.

Once the fabric is dry, you can add colors to the bleached-out areas. Pastels, acrylic or watercolor paints, or colored pencils work well on paper; dyes, fabric paints, and textile markers take nicely to cloth.

Black fabric hides many colors that bleach reveals. Leaf-printed and block-printed cotton fabric by Carolyn A. Dahl.

Moonscape: Fabric Bleaching Procedure

MATERIALS

- ❏ Masking tape
- ❏ Black 100-percent cotton fabric
- ❏ Branch
- ❏ White chalk
- ❏ 12 to 15 leaves, in assorted sizes
- ❏ One quart chlorine bleach
- ❏ Wide glass dish for bleach
- ❏ Newspaper
- ❏ One small- and one medium-size brush
- ❏ Neutralizer (gallon of white vinegar or Anti-Chlor)
- ❏ Plastic bucket (to hold neutralizer)
- ❏ Large bowl
- ❏ Large sheet of brown paper (should be 4 to 5 inches [10 to 13 cm] larger than bowl)
- ❏ Scissors
- ❏ Spray bottle
- ❏ Safety equipment: respirator, goggles, rubber gloves, and long-sleeve shirt

Our moon is moving away from the earth by several inches a year. Because I don't want it to leave, I try to catch it in my art. I invite you to do the same. Take a few minutes as you moon view to walk around searching for an interesting vantage point where the moon and the landscape interact. Use the scene to invent a moonscape of your own in any medium, or follow my instructions to create a bleached fabric moonscape. Either way, let your lunar mind improvise freely.

1 Tape fabric to protected work surface. Sketch the branch's outline in chalk on the upper part of the fabric. Repeat the process on the lower part of the fabric.

Wearing rubber gloves, dip leaves in 1 to 2 inches of bleach, and allow excess to run off. Lay leaves, vein side down, on the fabric. Cover the leaves with scraps of newspaper and rub or press. Make some extra leaf prints on a separate piece of fabric to fuse over poor prints if necessary.

2 Using the medium-size brush and bleach, fill in the branch outline. Use the small-size brush to connect the leaf stems to the branch. After the desired color is reached, place the fabric in neutralizer to stop the bleach's progress, then machine wash and iron before proceeding.

3 Invert the bowl on the fabric and trace its circumference with chalk to make a moon shape. With masking tape, cover any leaf prints and branches inside the circle, and the outer edge of the moon shape to protect them from the bleach.

4 Trace the bowl again in the center of a sheet of brown paper, cut out the circle, and align the hole with the moon shape on the fabric (double-stick tape on the back side of the paper helps it to adhere). Cover the rest of the fabric with newspaper. Spray the bleach solution lightly over the moon-shape opening. When the desired color is reached, remove the brown paper and newspaper and place fabric into neutralizer with masking tape still on.

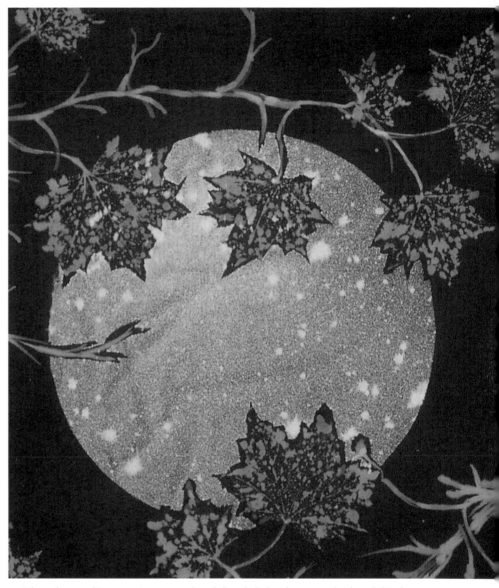

5 When the masking tape is removed and the cloth has been washed and dried, the moon will appear to glow brightly against the black fabric. (The completed piece appears in its entirety on page 41.)

Treescape: Creating Tree Bark

MATERIALS

- Scissors
- Black cotton fabric
- Masking tape
- PVC sewer pipe (4 inches [10 cm] in diameter, approximately 27 inches [69 cm] long)
- Ball of cotton twine
- One quart liquid chlorine bleach
- Foam applicator (or medium-size old paint brush)
- Glass dish or plastic bucket (to catch bleach drips)
- One quart neutralizer (white vinegar or Anti-Chlor)
- Plastic bucket (to hold neutralizer)
- Safety equipment: respirator, rubber gloves, long-sleeve shirt

Sometimes you can create a fantasy landscape in which you don't actually show the moon, but the viewer senses its presence through the light patterns on tree bark.

One way to create stylized bark that's flooded with moonlight is through the bleach and pipe-wrap technique. The fabric-covered pipe even feels like a real tree trunk.

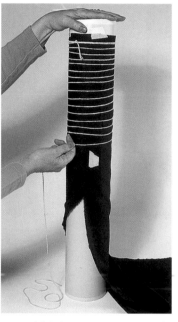 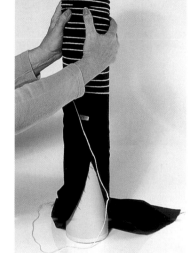 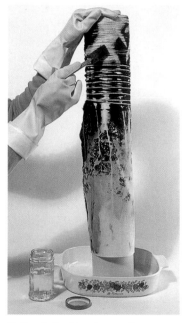

1 Cut fabric into strips approximately 14 1/2 inches (37 cm) wide and 36 to 40 inches (91 to 102 cm) long. Tape one end of the fabric strip to the top of the pipe, overlapping the fabric edges, and then tape the fabric closed at a few spots down the length of the pipe. Wrap the twine several times around the top of the fabric and tie it into a knot. Begin winding the twine around the pipe at intervals; your design will be more interesting if the spacing varies.

2 After winding about 8 to 10 inches (20 to 25 cm), push the fabric toward one end of the pipe until it forms tight gathers (if you have difficulty pushing the fabric up, flip the pipe over so you can instead push down). The twine and gathers of the compressed fabric will resist the bleach, creating black areas, while the exposed areas of fabric will turn white from the bleach. Repeat the process until two-thirds of the fabric strip has been gathered. Secure the twine with a knot.

3 Brush the bleach over the gathers, making a tree-trunk design (the tree is upside down on the pipe). If the fabric resists the bleach, slightly wet it first. Pour the bleach over the unwrapped fabric, catching the excess bleach in the dish. When the fabric reaches the desired color, place the tube in neutralizer. Rinse the tube and compressed fabric under running water.

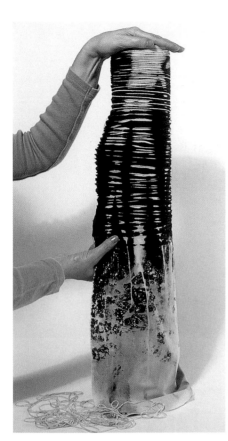

4 (ABOVE) Cut the twine and unwind the wet fabric.

5 (RIGHT) Turn the fabric right side up to see the tree trunks and canopies. After the fabric is washed and ironed, you can embellish the design with leaf prints, if desired.

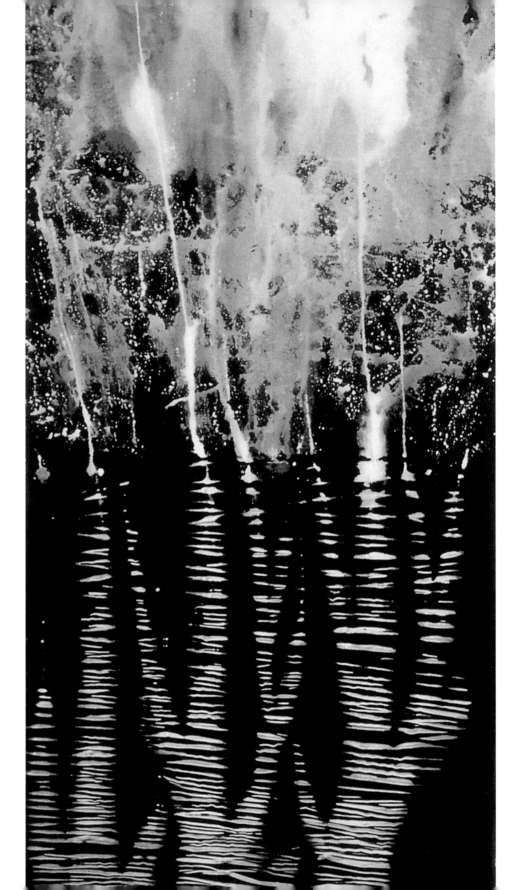

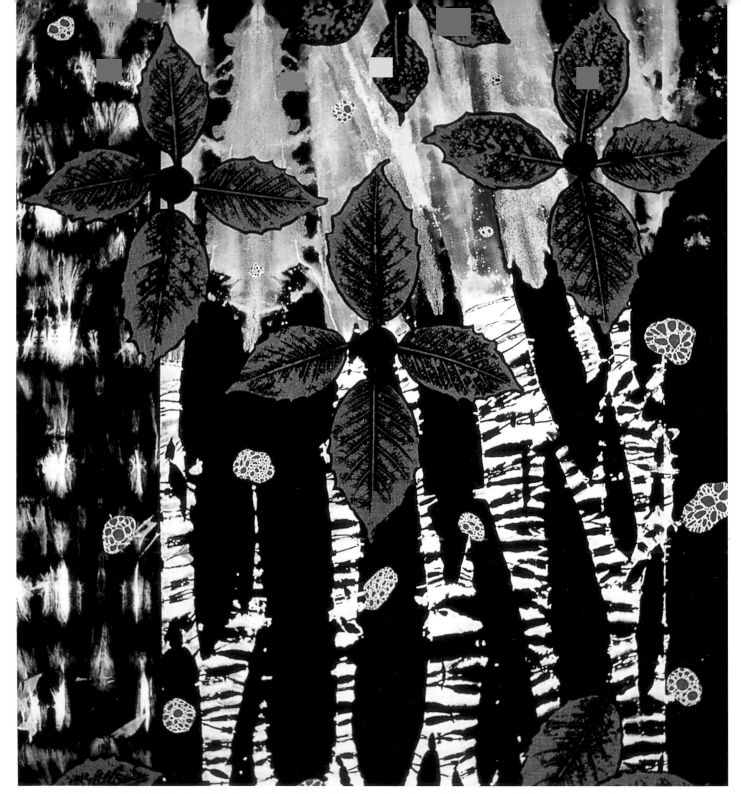

Treescape by Carolyn A. Dahl. Bleached leaf prints and pipe-bleached tree trunks. Cotton fabric. 29 × 34 inches (74 × 86 cm).

PAPER BLEACHING

Black cotton paper can also be bleached, but because it can't be washed in a machine to remove all traces of the bleach or the neutralizer, you can't be sure the paper will be archival if you plan to sell your work. The effects, however, are so intriguing that it's worth trying.

As with fabric, make tests on your paper to determine its bleaching ability and the strength of your solution. Apply the bleach to paper in whatever manner you choose, then slip the paper into a flat tray containing one part vinegar to two parts water. Large sheets of paper are difficult to handle when wet, so begin with smaller sizes. Unlike fabric, paper isn't a woven structure, so don't forget it in the neutralizer or it may fall apart.

Rinse the paper several times in a tray of clean water, and blot the paper on newsprint or paper towels to remove excess water. Because the paper will ripple if left to dry unstretched, use pins or tape to attach it to a board or another surface to dry. After the paper is dry, you can work back into the bleached areas with watercolors, stamps, embossing powders, pastels, glitter crayons, or colored pencils.

HINT

Undiluted bleach can damage rubber stamps. Soak your stamps in neutralizer after use, and don't select irreplaceable ones for this process. Handle undiluted bleach solutions with extreme care and wear protective equipment.

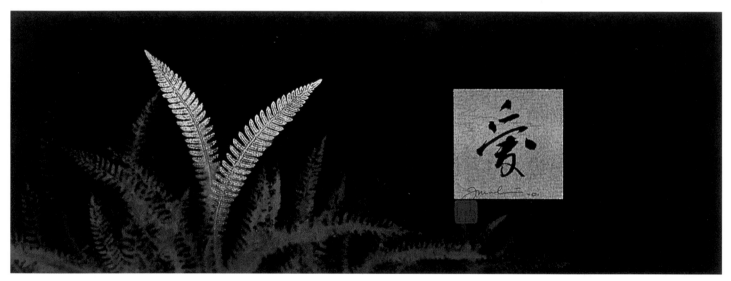

Deer Fern/Black #1 by Fred B. Mullett. Bleach and watercolor on Arches Black Cover paper. Deer fern stamp from Fred B. Mullett Co. Chinese seal courtesy of Red Pearl Rubber Stamps. Chinese calligraphy stamp courtesy of Hero Arts. 6 1/2 × 17 inches (17 × 43 cm).

The fern stamp was dipped into 100 percent bleach, sprayed with water to diffuse the image, and stamped onto Arches Black Cover paper. Then the stamp was again sprayed with water (to continue breaking down the detail) and stamped onto the paper. After the paper reached the desired color, it was neutralized with vinegar, rinsed, and allowed to dry. Transparent watercolor was used to color the now lighter areas of the design. A white image from the original stamp was placed on top of these diffused background images and highlights were added to heighten the sense of depth and color. The red Chinese seal was printed and heat-embossed with opaque red thermography powder, and the calligraphy stamp was printed in black on metal-foil paper and glued onto the work.

Freeing Childhood Spontaneity

A child in the top of a tree
throws her weight
back and forth,
rocks the green cradle
with only sky for ropes.
She doesn't know yet
she isn't a bird, or wind,
and more breakable than
the branches she holds in
her fingertips like bones.

Scribble, doodle, and color your way back to creativity.

CRAYON CREATIVITY

Buy a box of crayons. That's what I tell my students when they ask me how to become creative. What they're really asking is how to remember their creativity. We all have it, but we tend to forget it as we grow older.

To renew our imaginations, we need to remember our younger selves. We stopped to watch bugs waddle over grass and believed that plants could talk. Some of us petted spiders to compare our hair to theirs, or asked why the rain didn't put out a star's fire. Most of us created wild drawings with fantastic creatures because they were easy for us to draw. "They just came," we told our mothers. And they did.

Because they transport us back to the freedom of childhood scribbling, crayons are an important tool in an adult's re-creativity process. I buy a new box every fall. Even though the names of the individual colors have changed, just lifting the lid takes me back in time: the fragrant, waxy Peach I remember chewing, the joyful blast of Orchid that ruined my mother's linen tablecloth, and gentle Robin's Egg Blue that snapped in half like the thin eggshells I found in nests.

Crayons remind me that creativity isn't just a concept, it's something I make with my hands.

I thought the whole world of nature must be in the box, lined up by color. I knew color was everywhere, but seeing rows of blues, greens, yellows, and reds made color tangible to me. With so many choices, I believed I had the power to color anything into existence.

Crayons remind me that creativity isn't just a concept, it's something I make with my hands. And it should be fun. To children, art doesn't need a purpose other than pleasure. They don't criticize everything they make. They love their blue trees with scarlet leaves and huge-headed people balancing on stick legs.

When I want to rediscover that spontaneity and the pleasure of crayons, I invite a child on a nature walk to make leaf rubbings. The only supplies needed are pads of paper and a big box of crayons. If the experience is to revitalize my creativity, however, I can't think of myself as an adult watching a child explore nature. I must become an overgrown child, following the lead of a playmate.

Although copying a child's actions might feel uncomfortable at first, I stay with the process because it eventually releases the natural creative flow my body remembers. If I can physically play like a child in nature, I can mentally play like a child when I'm back in the studio. If the child covers a leaf with paper, grabs a handful of crayons, and furiously rubs back and forth, I follow her gestures, rubbing until flakes fly like colored sparks. If her interest moves from leaf rubbing to hair rubbing, I willingly lay my head on a slimy rock, ignore the bugs, and enjoy being rubbed. And I remember to join a child's laughter when he covers his toenails with paper to make a "smell print" or asks if a butt makes a good rubbing.

When I'm with children, I'm not interested in producing the perfect artwork, although good rubbings may result. I've come to nature to share the sparkle in a child's eyes as a leaf's texture magically appears on his paper and to remember the delight of simple tools like crayons.

Even artists need time away from the pressures of making "Art." Sometimes the best way to become creative is to take a break from creativity. Perhaps that's the secret of children, nature, and a fat box of crayons. They remind us to take time for recess.

Detail of *Crayon Cloth Vest* by Carolyn A. Dahl. See page 55 for the entire piece.

MAKING LEAF RUBBINGS

You can make leaf rubbings at home or in nature's beautiful living room, surrounded by birds, trees, and wildflowers. All you need is a crayon, a pad of paper, leaves, and a love of discovering hidden textures.

When making rubbings, lay the leaf under a sheet of paper in a notebook, hold the paper down with one hand, and use the other hand to rub over the leaf with the broad side of a peeled crayon. Cut out the leaf rubbing and glue it to another piece of paper. Or rub with fabric crayons if you would instead like to transfer the rubbing to fabric.

To make a two-color leaf print, color a light color, such as yellow, in a thin layer on the paper. Slip the leaf under the colored section. Using navy, deep purple, or brown make a leaf rubbing over the first color.

Many other objects from nature can be rubbed: tree stumps, weathered wood, stones, and termite tunnels in wood are just a few. Once you start making rubbings, the possibilities for further exploration are endless: lace, plastic nets and doilies, puzzles, flocked wallpaper, embossed greeting cards, soles of running shoes, and manhole covers will be seen in brand new ways.

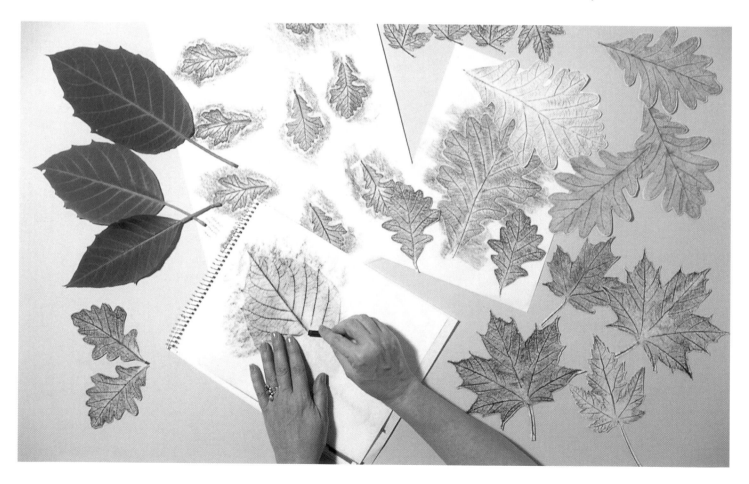

Creating a Crayon Cloth Vest

You can make a scribbled crayon cloth vest yourself or help a child to make one. The following demonstration was a collaboration and the result of a nature walk with a child. Fascinated by the movement patterns of falling leaves, she had spent most of her time imitating the motion. So did I, as she insisted I breathlessly join her in the "falling leaf dance."

In between performances, we did some rubbings. Instead of using regular children's crayons, I had taken along special fabric crayons so that any rubbings we did could be transferred from the paper to cloth with the heat of an iron. I call the resulting fabric crayon cloth, which can also be used for quilts, pillows, bags, handmade dolls, dollhouse rugs, or journal covers.

When we returned home, I showed her my crayon cloth vest and asked her if she'd like to make one for herself. She did. I allowed her to choose the theme. It didn't surprise me when she proposed, "What if people fell from the sky like leaves?" Her choice showed she had observed nature, tried it on like a dress, and imaginatively was ready to translate her experience into an artwork.

MATERIALS
- ❏ Crayola fabric crayons
- ❏ Child's vest pattern (avoid darts)
- ❏ Sheets of white paper (large enough to accommodate vest pattern pieces; avoid papers with plastic coatings)
- ❏ Black Sulky Iron-On Transfer Pen
- ❏ Leaf rubbings made with fabric crayons (optional)
- ❏ Masking tape
- ❏ Glue stick
- ❏ Fabric (see vest pattern for specific yardage; must be white, washed and ironed, 100 percent polyester or a blend of 65 percent polyester/35 percent cotton—a 100 percent polyester T-shirt could be substituted)
- ❏ Package of white tissue paper
- ❏ Iron and firm ironing surface
- ❏ Respirator (use in a well-ventilated room or a garage)

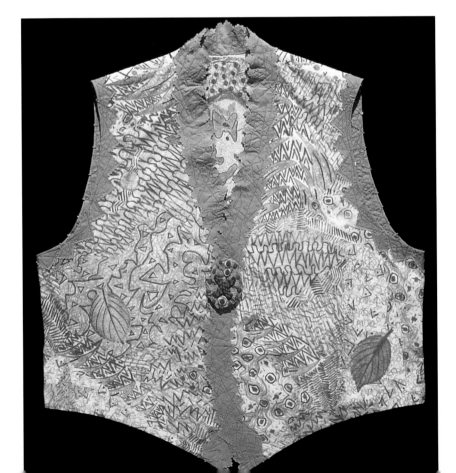

Crayon Cloth Vest by Carolyn A. Dahl. Polyester/cotton crayon cloth, quilted, polymer clay pin.

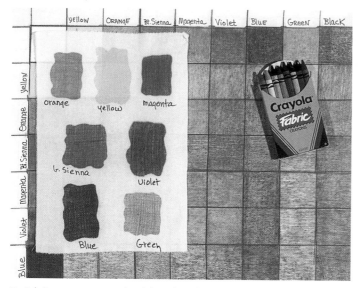

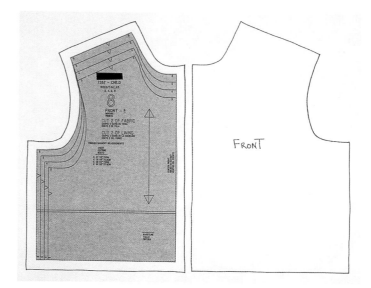

1 Fabric crayons come in eight colors, but they can be layered to create additional shades. The color on the paper won't be the final color, so make samples by coloring squares on paper and heat-transferring them to the fabric.

2 Lay the front pattern piece on white paper and trace with the transfer pen, extending the edges of the pattern about three-quarters of an inch (1.9 cm). Repeat the process on the back pattern piece, eliminating the back seam. Trace pockets, interfacing, or other pieces you want to color.

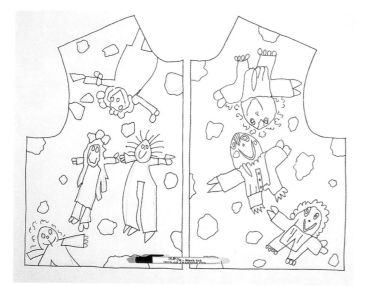

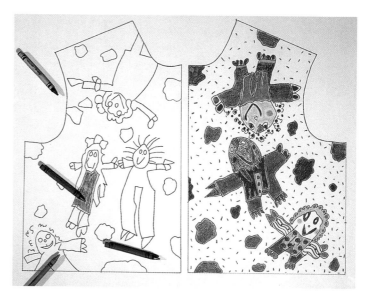

3 Have the child draw directly onto the paper with the transfer pen. (The pen contains the same dye as the crayons and will transfer as a black line around the crayon drawings.) Leave space in the design if you wish to add cutout leaf rubbings.

4 Together color the drawings with the fabric crayons. Press fairly hard to get a rich color. Pick up any crayon flakes with masking tape to prevent unwanted color specks in white areas.

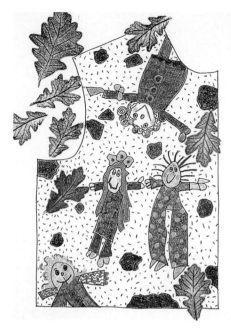

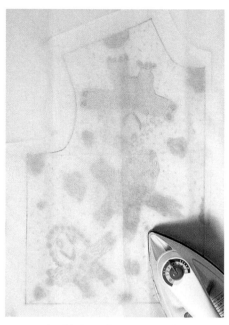

5 Glue the cutout leaf rubbings onto the paper with a glue stick.

6 Lay one vest piece, colored side down, on the white fabric. Tape the edges to prevent shifting. Choose an ironing surface that is firm, texture free, and heat tolerant (such as smooth mat board placed on an old worktable). All ironing is to be done by an adult, not the child.

7 Tape the fabric to the ironing surface. Cover vest piece with tissue paper and iron on the cotton setting (or the hottest setting that won't scorch fabric). Do not use steam. Heat each section of the design, slightly moving the iron to avoid steam-hole marks. Don't return to an ironed section. Check to see if colors have transferred by carefully lifting a corner of the paper while keeping the iron in place.

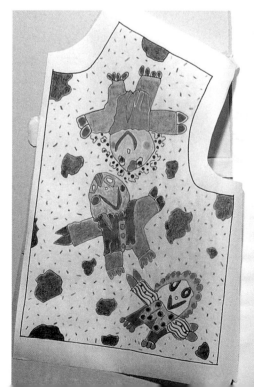

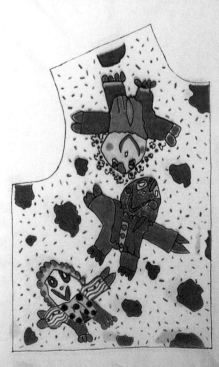

8 Remove tissue paper and vest piece. The design on the paper has permanently transferred to the fabric. Repeat the process for each piece. Then cut out the vest using original pattern pieces and sew together. The vest may be machine washed with cool water, on a gentle cycle, although hand washing is preferable. Line dry only.

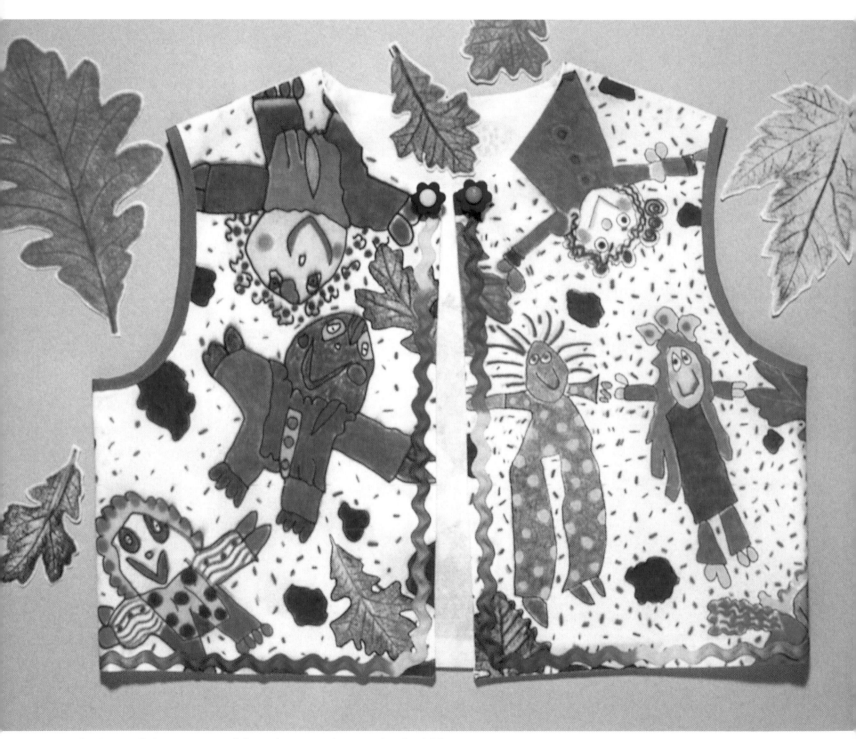

The *Crayon Cloth Vest* captures all the exuberance and spontaneity of a child's response to nature.

COLORING BOOKS AND
LAP LABYRINTHS

My students, having bad memories of being forced to color within the lines as children, express surprise when I recommend coloring books with nature themes as creativity tools. But coloring preplanned designs can maintain your connection to art on days when you haven't time to pull out your paints. Enjoying the colors' beauty and the back-and-forth movement of your hand can refresh your creative spirit as much as a quiet walk. Many people feel as if they are touching an actual leaf or flower as the crayon moves across it.

Another creative tool for hectic days is a wall or lap labyrinth. You can make your own by drawing, painting, or constructing one from handmade paper. Follow a traditional design from a book or compose your own. (See *Mazes and Labyrinths* by W. H. Matthews or *Walking A Sacred Path* by Dr. Lauren Artress.) Add rocks, twigs, dried wildflowers, wasp's paper, or other beautiful objects you've collected in nature. Then walk your labyrinth with your eyes or fingers. Some people like to walk the labyrinth path with their eyes so they can remain in a meditation posture. Others like to trace the pathway with their fingers, a crystal, or a favorite stone because the repetitive physical action quiets their minds. You can also follow the path with your nondominant hand, which some believe will activate the intuitive side of the brain.

Think of your labyrinth as a space, like the coloring book, where you place your busy mind. You don't think about creative

goals, but surrender to the journey as you surrender to the lines in a coloring book. The labyrinth is also an encouraging symbol on which to focus during traumatic or difficult times. It reminds us that although something may look confusing, there's always a way out. You may feel you're not making progress toward solving your problems, but like the labyrinth path, you are getting nearer to the center no matter how slow your pace.

Collected Paths (detail) by Ingrid Thomas Hooker. Handmade and cast paper, ceramic shards, wire, screening, stones, thread, and paint. 31 × 39 inches (79 × 99 cm).

Colored abaca and cotton paper pulp was hand-cast over a pre-sculpted labyrinth (foam pieces glued to a Plexiglas base and coated with latex). After the piece was dry, it was removed from the base and additional materials were added.

Flower

Impressions

Learning to Love Daydreams

The hummer returns to its feeder,
dangling a hanging raindrop on its tail,
until the flick of a transparent wing
sends the flying heart blinking and
buzzing off with whatever it knows.

Searching for the Gift (detail) by Carolyn A. Dahl.
See page 73 for the entire piece.

INSIDE A HUMMINGBIRD'S DREAM

Once a year, my garden feeds a miracle—the ruby-throated hummingbird. Looking at its thumb-sized emerald body, iridescent feathers, and speed-blurred wings, I feel like I own a fairy. I've wasted many art-making hours sitting amidst the flowers, leisurely watching it dart past me to drink from one nectar-filled bloom after another.

Today, the hummer is furious with me. Chirping stridently, wingtips buzzing my face, it attacks as if I'm an invader. All I want is a quiet morning in the garden to work on my half-finished, handmade paper bowl while I enjoy the purple torenia flowers and bright orange cosmos. Instead, I'm tense and alert as the tiny fighter plane skims over the tall hollyhocks and dive-bombs my hands with its ice-pick bill.

Moving the fragile, red bowl to the far side of the patio, away from the main flower beds, I hope the hummer will eventually ignore me. I don't understand its sudden hostility. For years, we've shared the garden peacefully. I provide the flowers, boil the sugar solution for its feeder, and dutifully keep it filled every three days in spite of drenching rain, broiling sun, and lightning storms. It provides beauty.

Like the hummingbird, I'm a small thing dreaming big dreams.

I've been a willing slave. The hummer, flashing through flowers like a "glittering fragment of the rainbow," as John James Audubon called the birds, has been my reward. But as it barely misses my eyes, I feel I'm the unwilling participant in a hostile knife-throwing act. Even though I'd like to watch the cardinal near the white alyssum and smell the hint of sea salt in the Gulf air blowing across the sunflowers, I surrender the garden and move inside to the sunroom. At least I'll be able to enjoy my flowers through the windows of two large French doors.

To my surprise, the angry hummer follows me, sliding from one little window to the next like a green jewel on an invisible thread. Its gaze is unsettling. Each eye is like an onyx bead, with a stare so direct and intense, the white dot of reflected light might be its soul. When its beak clicks against the glass, as if it hoped to chip its way into the room, the sound shatters my misunderstanding. The hummer wasn't after me; it wanted what I had—the largest, most beautiful cup-shaped flower it had ever seen. My red, twelve-inch (30-cm) paper bowl was a hummingbird's dream, and it would fight even me to attain it.

I've never developed the skill of recognizing the right-sized dream either. Like the humming-bird, I'm a small thing dreaming big dreams. I can exhaust myself with garden plans, hover all day with catalogues, desire the exotic blooms but ignore the simple, growable flowers. The hummer and I share impractical imaginations.

Hummers ignore bird boundaries. Each one may weigh about the same as a nickel but carries a load of magic into my garden. Its wings can twist in figure eights while hovering, or move at 2,280 revolutions per minute while flying, creating hypnotic whirring sounds in my ears. It can greet me eye-to-eye, dangle like a charm about to speak, then fly almost upside

down over the little mouths of snapdragons. Once I held a rubythroat in my hand, but its heartbeat was too fast to feel. Instead, the throb of 250 breaths per minute made my life seem slow and plodding. How could this bird have mundane dreams when it sleeps in a nest of spiderwebs hung with bits of colored lichen and lives each day gathering the sweetness of flowers?

Hummers deserve fantastic, improbable dreams. So do I. However, I used to attack my daydreaming self. Sitting in the garden in the morning, sipping coffee swirling with milk, I'd imagine paintings, collages, prints—one magnificent artwork after another. Half awake, I'd love the surge of ideas pouring out of my nighttime mind and the swell of creative energy growing in my body. But later, I'd feel guilty, as if I had wasted time, smelled too many roses.

But creativity isn't creativity if it's kept within tight borders or shackled with criticism. I had to learn to value my daydreams. After all, I'm an artist; imaginative dreaming is my job. I'd spent my life nurturing and practicing skills of visualization, inventiveness, and imaginative wanderings. I wasn't procrastinating. My daydreaming mind was doing what I had trained it to do—take me beyond the boundaries. Now I give my daydreams as many hours as they need, without guilt.

Creativity is not about practicality. I don't have to use every idea that appears, but the options need to continue sprouting. If I respect my daydreams, all of them will nourish me whether I plant them in the dirt of reality, in the air of imagination, or inside a hummingbird's dream.

Red Bowl by Carolyn A. Dahl. Hand-dyed, handmade paper pulp from abaca and cotton. 12 inches (30 cm) (height) × 18 inches (46 cm) (diameter).

PRINTING YOUR GARDEN:
FRESH FLOWERS

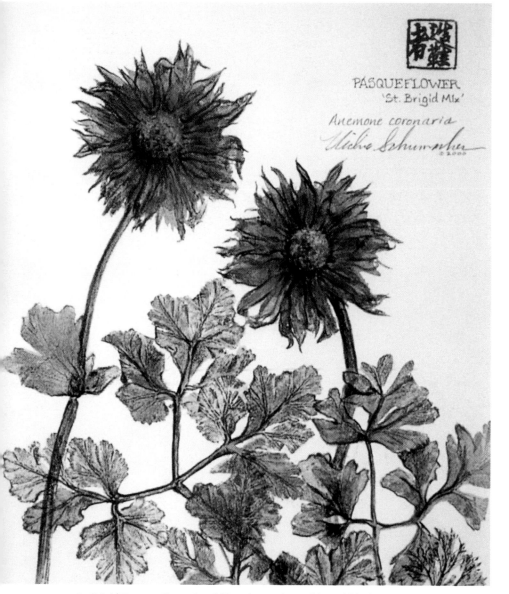

PASQUEFLOWER
'St. Brigid Mix'

Anemone coronaria

Vickie Schumacher
©2000

St. Brigid Pasque Flower by Vickie Schumacher. Oil-based block-printing ink and acrylic color washes on printmaking paper. 18 × 19 inches (46 × 48 cm).

Daydreaming and gardens have inspired creative people throughout the centuries. Poems used to be thought of as flowers, and poem collections were called anthologies or flower garlands (from the word *anthologia*: *anthos* means flowers and *logia* means collection). Connecting posies and poems seems right to me when I think of making flower prints. The poem documents a brief moment in time, and the flower print forever catches the brief beauty of a garden. Each print becomes a visual poem written in the language of flowers.

When printing flowers, use the same procedure as with leaf printing: brush or roll ink onto the flower, lay it on paper or fabric, cover with tissue, and rub. Many flowers wilt quickly, so have all your supplies ready before you pick the flowers, or keep the flowers in water until you're ready to print. Some flowers may need to be slightly flattened (to make them easier to ink) by placing them in a telephone book for a few minutes.

Flowers that have many leaves or stems are difficult to paint and press. Either remove some stems or cut apart the sections and print them individually. But before you do this, trace their intact shapes on a separate piece of paper or mark your printing paper with faint guidelines. This will help you reconstruct the original design. After printing the flower in a dark ink, acrylic or water-color washes can be added for color.

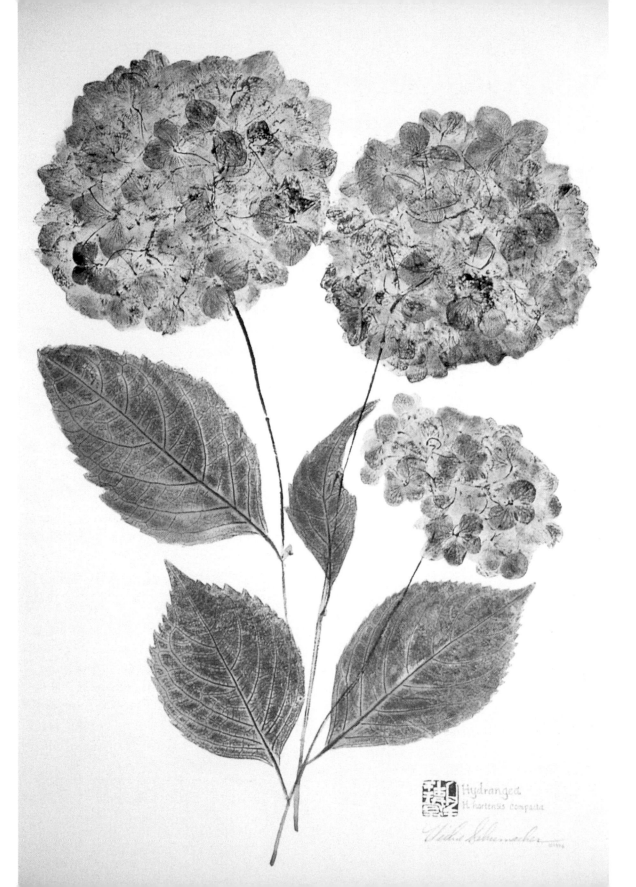

Hydrangeas by Vickie Schumacher. The hydrangeas were printed, and then individual petals were inked and hand-placed with tweezers for added petal definition. Oil-based block-printing Ink and acrylic color washes on printmaking paper. 22 × 30 inches (56 × 76 cm).

TRACING YOUR BIRTHDAY ROSES:
FLORIST FLOWERS

"Why do you keep dead flowers around your house?" a friend asked. She was talking about my birthday roses from a month before. I couldn't answer. I hadn't thought of the flowers as dead, but merely in transition to a grayer, drier, subtler beauty.

If I had thrown them out I would have missed the torque of thready stems, the petals' changing colors, and the sharp beauty of thorns when the leaves collapse. And I would have missed the inspiration for my birthday drawing.

My yearly ritual is to create a birthday artwork that captures something about the day. That year, my husband's long-stemmed roses, perfect in bud, never opened. Deprived of their expected lushness, but intrigued with their bony beauty, I decided to focus on the roses' less popular characteristic—the thorns.

I laid some dried flowers, leaves, and fallen petals on the paper and traced their contours. The dominant compositional shape became a large thorn, which occupied only one third of the available space to give a sense of something missing. After color was added, I enclosed the drawing with a border of tiny thorns that jutted out like a barbed-wire fence.

Dried roses can be traced and developed as realistic flowers or interesting abstract shapes that can be used in watercolor compositions or fabric patterns.

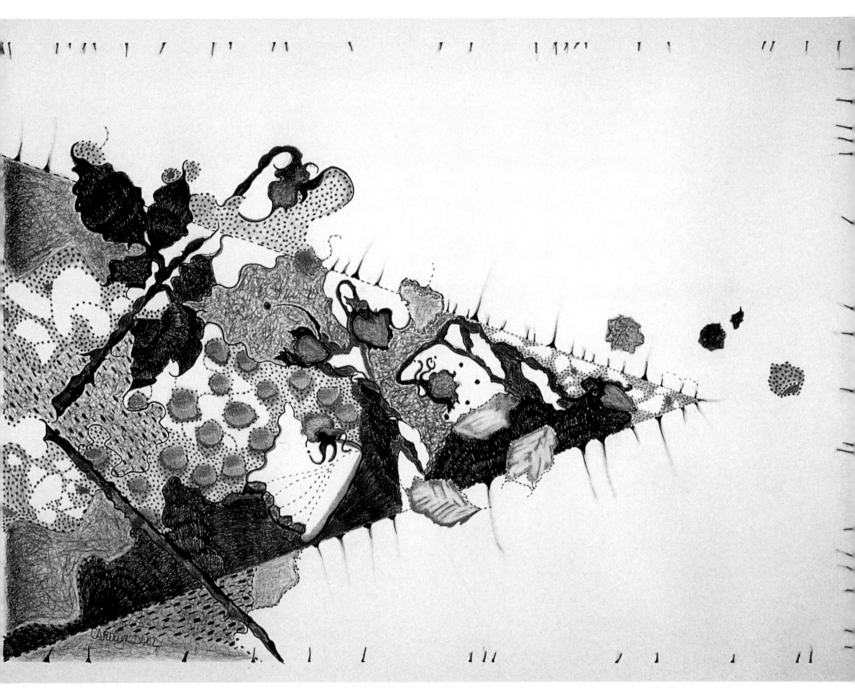

The Flowers Never Opened by Carolyn A. Dahl. Graphite, colored pencils on Bristol board. 22 × 30 inches (56 × 76 cm).

PRINTING WHILE IT SNOWS: DRIED AND PRESSED FLOWERS

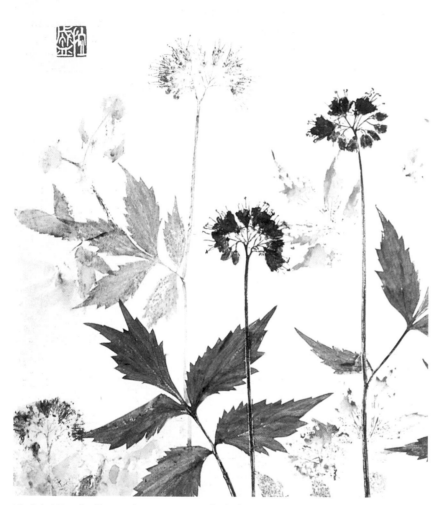

Virginia Waterleaf by Sonja Larsen. Instead of inking the flowers and immediately pressing them to damp paper, Sonja painted the pressed plants with tube watercolor and let them dry. Then she pressed the flowers on damp Arches 88 printing paper, which rewet the watercolor on the plants and transferred the images. Enough color remained on the plants to do a second ghost print behind the darker impression. 9 1/2 × 11 1/2 inches (24 × 29 cm).

When your garden is in full bloom, you can dry and press flowers to print during the winter months. Opening a box filled with last summer's pressed blooms while snowflakes fly outside is a special pleasure. If you don't have your own garden, become friends with a florist who might give you discarded flowers to press in exchange for a few flower prints for the shop.

Many beautiful flower presses can be purchased that add to the pleasure and ritual of pressing. But I also like to use old telephone books because they have a pulpy, earthy feel. When you lay the flower on the page, be sure the petals and leaves aren't bent or folded before you close the book. After a few days, move the flowers to clean pages to prevent mold. Discard the soiled pages. If your flowers stick, gently tap the back side of the paper to release them. Continue to change pages until the flowers are completely dry. Move them to another telephone book marked "ready for printing" or sandwich between sheets of tissue paper in a flat box.

Most dried flowers can be printed as is on damp paper, but if your flowers don't accept paint easily or are so brittle that they might break, place them between damp newspapers for an hour or overnight before printing.

MONOPRINTING OVER FLOWER BLOCKOUTS

Pressed flowers and leaves can act as masks to block color from areas during monoprinting. In *Old Garden,* for example, I placed dried carnations and assorted leaves on white cloth with double-sided tape. A sheet of freezer paper was painted with blue fabric paint and immediately laid over the flowers. The back of the painted paper was rubbed by hand to transfer the blue color to the cloth. When the paper and flowers were removed, the plants' shapes retained the white of the fabric.

Old Garden by Carolyn A. Dahl. Monoprinting, discharging, appliqué on cloth. 24 × 31 inches (61 × 79 cm).

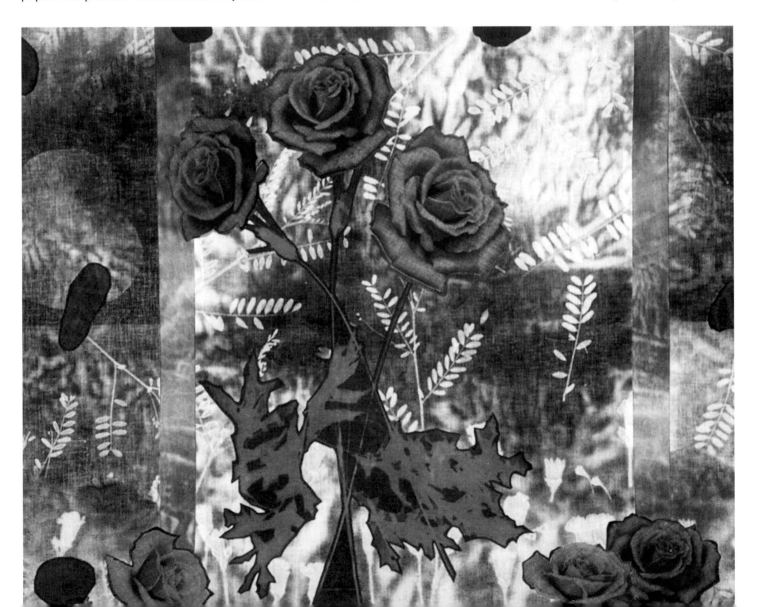

CREATING NATURE BOARDS

Nature boards are created by adhering pressed flowers and leaves to mat board. Select pressed and dried flowers and leaves that have a relief surface, even after pressing (carnations with many petals, daisies with raised centers, etc.). Coat one side of the pressed flower with waterproof glue and press it to the board. When the arrangement is complete and the glue has dried, cover the front and back of the board with two coats of gesso. Nature boards can be painted with watercolors or acrylics and left as finished artworks, or can be used as hand- or press-printing plates. If you use a nature board as a hand-printing plate, paint the surface, invert a sheet of paper over the board, and rub to transfer the design. The image will be delicate, almost ghost-like, which is a perfect background for "photocopy" collages.

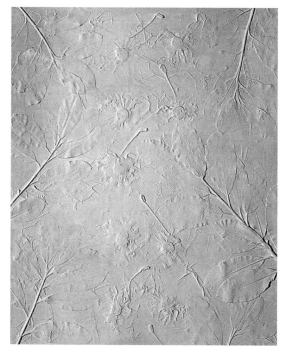

ABOVE: A nature board ready to paint or print. Daisies and leaves have been glued to the mat board, allowed to dry, and then covered in gesso.

RIGHT: A painted nature board that will be left as is.

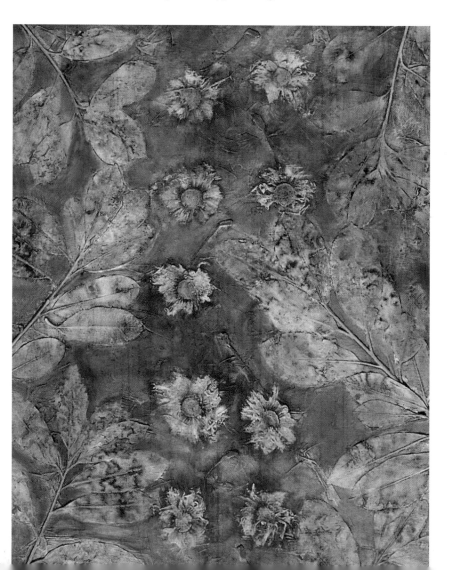

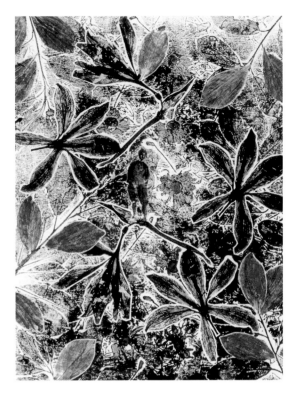

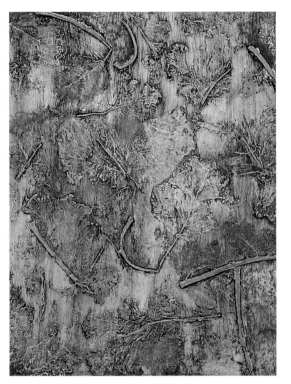

FAR LEFT: *Searching for the Gift* by Carolyn A. Dahl. Nature-board print with photocopied flower prints, collage, pastels, photo transfer, and leaf prints. 15 1/2 × 19 inches (39 × 48 cm).

LEFT: A second nature board painted with inks and pastels.

BELOW: *Visions Lost, Visions Gained* by Carolyn A. Dahl. Background printed with the nature board at top right on watercolor paper. Photocopied flower prints, collage, photo transfer, and fabric. 16 × 27 inches (41 × 69 cm).

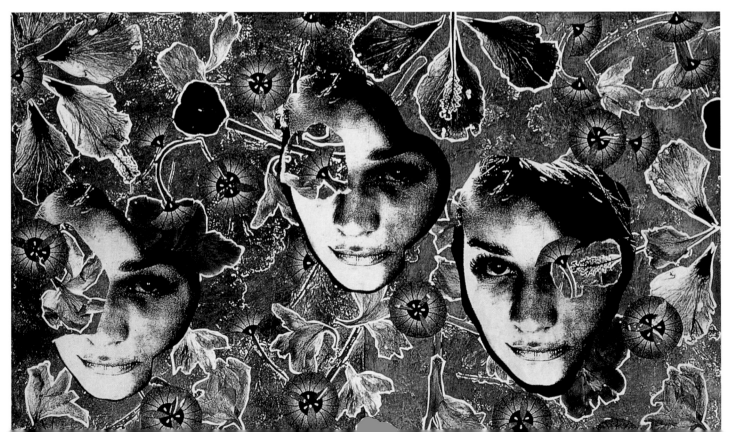

Fusing Photocopy Collages

MATERIALS

- 6 to 8 dried flowers
- Black-and-white photocopies of the flowers (made at various light and dark settings)
- Adhesive web (paper-backed Wonder-Under from fabric store)
- Scissors
- Tissue paper (two pieces for each photocopied flower, cut several inches larger than each flower)
- Iron and ironing surface (protect with an old sheet)
- Background composition
- Clear acrylic spray fixative

Flowers left to dry for a very long time become so thin that the light of a photocopy machine can reveal their inner structure, almost like an X ray. Delicate flowers (pansies, hibiscus, angel's trumpets) or plants with few petals work best. But others give nice dark prints for contrast. Press the flowers until they are very dry, like old paper.

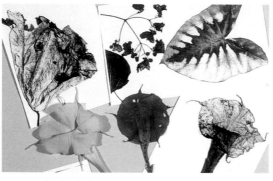

1 Press the fresh flower until it is thin and dry. Photocopy the dried flower and other plants you might use in your collage, varying the light and dark settings.

2 Select the best photocopy and lay it on the rough side of the adhesive web. Cut adhesive web to match the size of the photocopy.

After the flowers have been photocopied, I find that fusing the images to a background composition (such as a collage you've previously started, a watercolor, or a nature-board print) works better than glue on the thin photocopy paper. For fusing, use an adhesive web meant for fabric bonding (like Wonder-Under transfer web, sold in fabric stores).

3 Cover the two pieces (the photocopy and the adhesive web beneath it) with tissue to protect the iron. Press with hot, dry iron to fuse the web to the photocopy. Follow manufacturer's instructions to ascertain the temperature and length of time to iron. Cut out the photocopied flower, leaving a thin border of white around the image.

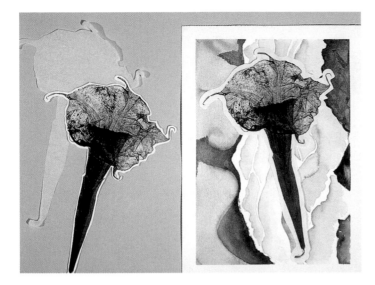

4 Peel off the paper backing from the adhesive web. The adhesive from the web will have transferred to the back side of the photocopy. Position the photocopied flower on your background paper. Cover with tissue again and iron flower firmly into place. Do not use a damp press cloth or steam, or the paper will wrinkle. Repeat this process, using additional flowers, until all elements of the design have been fused in place. When the collage is complete, spray the artwork with an acrylic spray fixative to preserve the photocopy ink.

TREAT YOUR ANGELS WITH CARE

The more exotic and unusual the plant, the more it attracts me as an artist. Sometimes, however, beautiful plants we live with daily (like oleander, iris, poinsettia, angel's trumpet) can become poisonous if handled carelessly. If you choose to use the angel's trumpet in the photocopy process (many other plants can be substituted), do not consume any part of it or allow children to play with its flowers or leaves. Always wash your hands after handling.

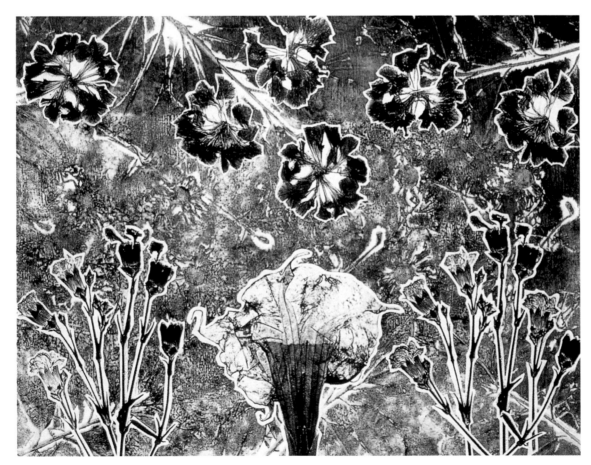

Eyelid Landscape by Carolyn A. Dahl. Photo-copied flower prints, collage on printmaking paper. 15 1/2 × 19 inches (39 × 48 cm).

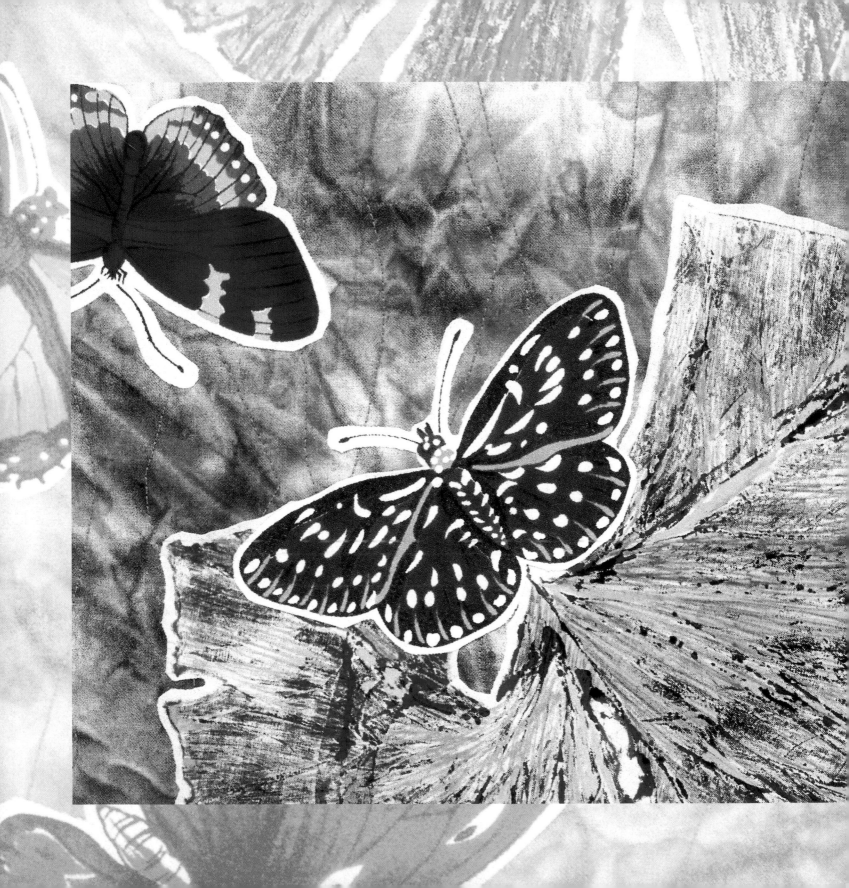

Living with Butterflies

*I've never gotten over the disappointment,
of being born without wings.*

Detail of *Butterfly Quilt* by Carolyn A. Dahl.
See page 79 for the entire piece.

FLYING FLOWERS

For days, I lived in a cloud of butterflies. Morning to evening I stayed by the trees. I was there when thousands of wings lifted in the warm sun. I was there when they returned at dusk, folding their delicate fans, bending oak limbs with the weight of wings. Everyone receives at least one unexpected miracle from nature. I knew this was mine.

I was ill that summer. A battery of medical tests had exhausted my body and spirit. Totally depleted, I turned to nature for revitalization. But I found I craved a deeper, older connection to nature than my adopted home offered. I needed my childhood soil. The land of my birth has always held special healing powers for me. Maybe it works because there's a match between the minerals in the soil and the minerals in my body, raised on garden food. Or maybe the familiar landscape makes me feel secure and centered, which increases my immunity. However it works, I was sure I'd find what I needed in the land of my childhood: Minnesota.

> *Everyone receives at least one*
> *unexpected miracle from nature.*
> *I knew this was mine.*

When I boarded my flight, something else was in the sky miles away—thousands of black and orange wings. A day after my arrival at my parents' home, I awoke to find every tree in the woods carpeted from canopy to root with monarch butterflies. The abundant supply of milkweed in the fields, a creek below the house for moisture, and acres of undisturbed land probably caused the migration to choose our property as a resting spot. But I believed they were the gift that Minnesota had promised.

Nature knew that one or even ten butterflies couldn't help me. I had drained my inner resources to the starving point. Deadlines, teaching, and gallery shows had made me forget to take the time to replenish the source from which everything comes—my internal reservoir of beauty. A few butterflies could make me smile, but to awaken my depleted spirit, to strengthen my body, a hurricane of wings, an overwhelming onslaught of beauty, would be needed. So nature sent me a migration. And it worked. By the time the butterflies left, I had grown stronger and knew the worst was over.

The butterflies never came to my parents' home again. But a few of their descendants pass through my garden on their migratory path to Mexico. In gratitude for what the Minnesota butterflies gave me, I've turned my kitchen into a monarch butterfly nursery. Twenty-five pots of milkweed attract adult monarchs to my garden. When the eggs hatch into pinpoint caterpillars, I bring the plants inside, away from the marauding wasps. For weeks I care for the growing caterpillars, telling them how beautiful they'll be. I speak loudly, which causes them to rear up and nod their heads.

When they grow restless, searching the back side of every leaf but not eating, I know transformation is near. On the edges of the milkweed pots, I place chopsticks, which the

caterpillars use like planks to crawl to a nearby basket. There they park on the rim and spin their silk hanging cords. After a day, they drop upside down, dangling until the magical moment, when each turns from a striped caterpillar into a chrysalis the color of jade.

Once in a while, however, I raise creative caterpillars. They like to wander, seeking unusual environments. Avoiding the basket, they'll climb to the ceiling, hike the room to the underside of a chair, or hide inside our metal dinner bell. One even scaled the slippery side of my husband's handmade teapot, hanging from the very tip of the spout. As its chrysalis color matched the pot's celadon glaze, I named it Green Tea Drop.

When it hatched, and after its wings grew hard, it played with me as I had my morning coffee. Dragging its soft orange cape lightly across my arm, it fluttered to my shoulder and shook a threadlike leg at my nose. When I took it outside on my finger, I placed it next to a red hibiscus flower. A bee gathering nectar nearby immediately approached it like a flower, but Green Tea Drop flapped its wings to brush it away. The bee returned again and again until, annoyed, my teapot butterfly lifted off. As I watched it leave, orange wings spread out like dark-veined petals, I remembered a saying from my childhood: A butterfly is a flying flower.

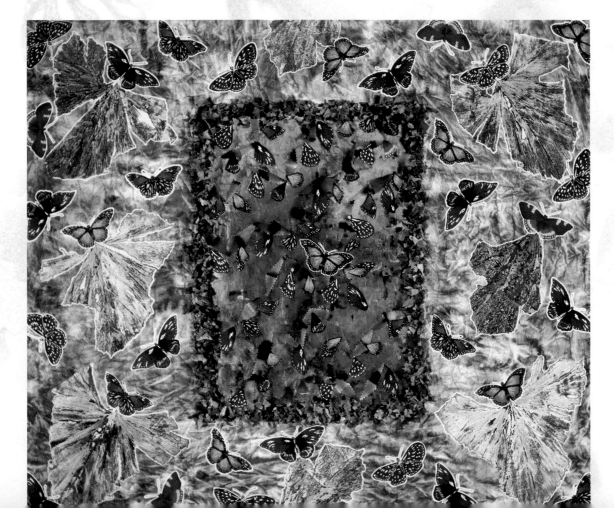

Butterfly Quilt by Carolyn A. Dahl. Leaf prints, ZIG textile markers, hand-dyed fabric, appliqué, quilting. 43 × 38 inches (109 × 97 cm).

Printing Wings

MATERIALS

- Butterfly
- Clear acetate
 (2 pieces, approximately 9 × 9 inches
 [23 × 23 cm])
- Sharpie permanent
 marker (black, fine
 point)
- X-Acto knife
- Cutting surface
- Tweezers
- Black Speedball
 Oil-Based Block
 Printing Ink
- Glass or Plexiglas
 palette (or freezer
 paper taped to
 work surface)
- Soft rubber
 printmaking brayer
- Turpenoid
- Masking tape
- Scrap paper
- Printmaking paper
 (Rives BFK,
 dampened slightly,
 approximately
 7 × 10 inches
 [18 × 25 cm])
- Tissue paper (one
 piece per wing,
 each cut larger
 than wing)
- Tampo (see page
 101; or substitute
 cosmetic sponges)

You can invite butterflies into your life by creating a butterfly garden that supplies their food sources. Even a few plants of milkweed will attract monarchs to your yard. Or, if you don't have an outdoor space, butterflies can be ordered as caterpillars so you can enjoy the miracle of a butterfly hatching in your own home.

If you're patient and watch constantly for butterfly wings, eventually you'll find some to print. (Please don't destroy live butterflies.) Maybe you'll be lucky and find a whole butterfly, but one wing, even a very tattered one, will make a beautiful print if you use it to print all four wings. While you're waiting for your wings to arrive, you might try creating a fantasy butterfly from small leaf prints (see pages 20 and 21).

Several different methods can be used to print butterfly wings. You can hand paint the butterfly body on the paper and then print the four wings around it. Or you can do the reverse: print the wings first, eyeballing their position, and then paint in the body. If you prefer to have some placement guidelines, you can use my acetate stencil method, in which the inked wings are fit into stencil openings. This technique works especially well if you are interested in creating a print with a particular butterfly-wing position.

Remember that butterfly wings are made of fragile veins and delicate scales, so treat them gently. Depending on how old the wings are (very brittle wings can be placed

between damp newspapers to increase their moisture and flexibility), you can expect only two or three really good prints. After that, the results can't be predicted, as the wings often tear or become too thin to rub. But because every wing is a gift, I use each one until it looks like it had flown a thousand migrations under every adverse weather condition. Sometimes those frayed, ragged-edge wing prints are my favorites. When I've reduced each wing to colored dust on my fingertips, I feel I've forever caught in ink the spirit of my short-lived butterflies.

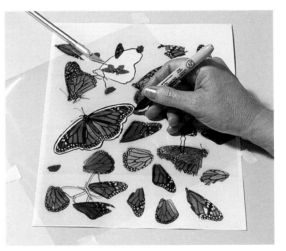

1 Make a color photocopy of your butterfly (or wings). Place a piece of acetate over the photocopied butterfly and secure it with masking tape. Trace the outline of the wings and body (enlarging them slightly) with the marker. Using an X-Acto knife, cut out the wing shapes, leaving the shape of the body intact. Repeat with a second sheet of acetate, this time cutting out the body and leaving the wing shapes uncut.

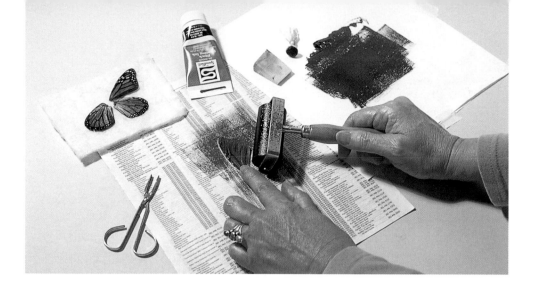

2 Remove the wings from the butterfly with the tweezers. Roll out the ink on the palette with the brayer (add a touch of Turpenoid to thin if necessary). Place the top left wing on the scrap paper, hold the tip (where it connected to the body), and gently roll the inked-up brayer in one direction over the wing's back side.

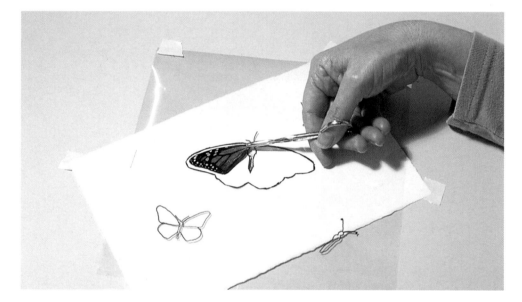

3 Place the first stencil over the print-making paper. Using the tweezers, position the wing in the stencil's opening. Be sure that no edge of the stencil is under the wing.

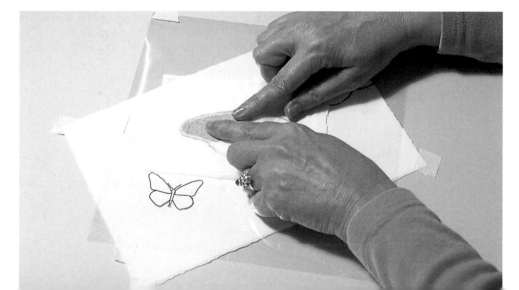

4 Cover the wing with tissue paper and gently rub with your finger. Remove the tissue, leaving the wing in place. Proceed to print the lower wing, which will some-what overlap the top wing. This will create a finished print in which the bottom wing looks like it's behind the top wing.

81

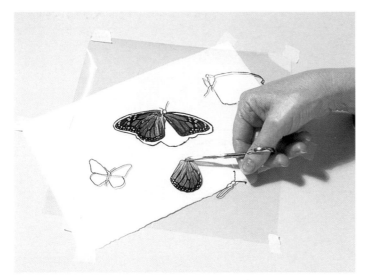

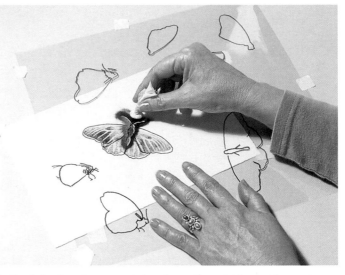

5 Continue the process until all four wings have been printed. Then very carefully remove the wings and the stencil. Allow the print to dry somewhat before proceeding to the next step. You can make other wing prints while you wait.

6 Carefully place the second stencil over the print to avoid smearing the fresh ink, positioning the stencil opening where you want the butterfly body to appear. Dab the tampo into the rolled-out ink, and gently tap the ink into the stencil's open area.

7 Remove the stencil. Your butterfly print is now complete. After the ink is totally dry (oil-based inks may take anywhere from two days to two weeks to dry), you can add color to the print with watercolors or colored pencils. The two buff-colored butterflies were printed from the tattered top wings of various butterflies.

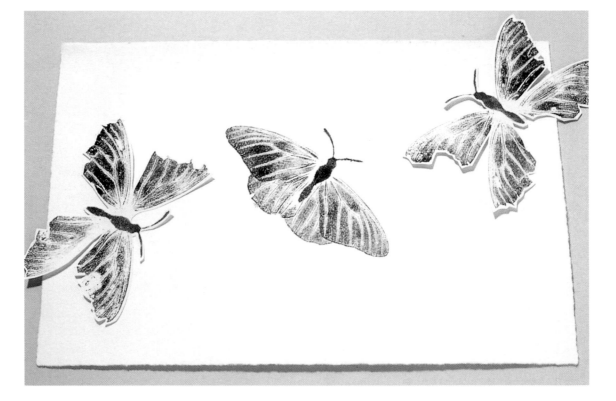

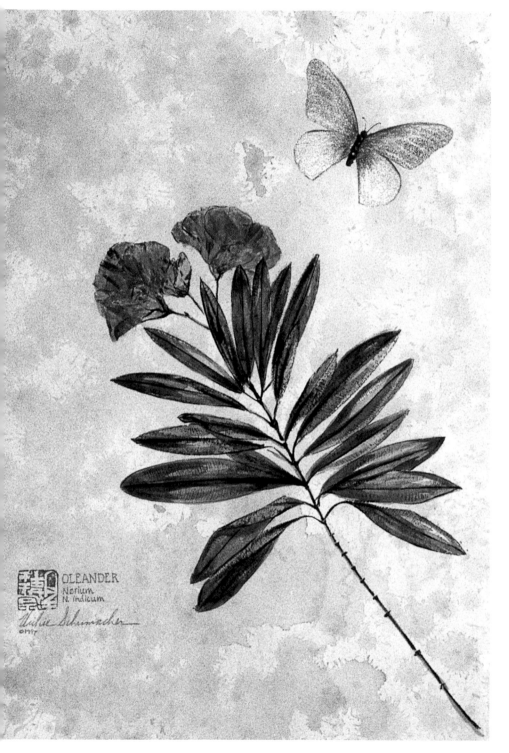

ABOVE: *Dragonfly* by Vickie Schumacher. Oil-based block-printing ink on printmaking paper, tea-stained background. 6 × 9 inches (15 × 23 cm).

LEFT: *Oleander with Butterfly* by Vickie Schumacher. Oil-based block-printing ink with acrylic washes on printmaking paper, gold metallic paint on butterfly, tea-stained background. 16 × 20 inches (41 × 51 cm).

LONG BRUSH OF THE MIND

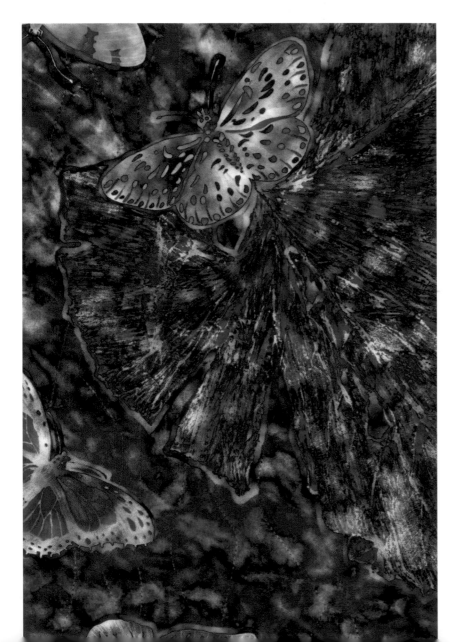

Variation of *Butterfly and Leaf Print,* from *Butterfly Quilt* by Carolyn A. Dahl (see page 79). Photoshop filter: Render and Difference Clouds. 8 1/2 × 11 inches (22 × 28 cm).

My early resistance to computers was simple: I didn't like their looks. Utilitarian plastic boxes in limited color choices, with no textures, strung together with a plethora of cords and plugs, created no desire in me to interact with them artistically.

I wanted all my art-making tools to have an aesthetic presence and a sense of spirit. When I held my Chinese brush and felt the indentations of the engraved gold calligraphy on the black lacquered handle, or touched the white bristles pointed to a flower-bud tip, its beauty affected me. I was inspired to create something that matched its aesthetic standards. But the brush also had a special spirit because it had a history. Whenever I lifted the brush by its red satin cord, I remembered my Asian friend presenting his surprise gift, his fingers on the glossy handle, proudly translating the golden calligraphy:

| The stroke should be made in one breath. | Your proper force can penetrate the paper. | By nighttime you can dream about the beautiful blossom your brush creates. |

Although my computer came with megabytes of memory, I couldn't find a way to make memories with it. Even after several months together, I still felt no emotional or aesthetic connection between the machine and my life, as I did with handheld tools. No memories flickered when I turned it on and none lingered when I turned it off and the screen faded.

Also, I missed the physical relationship I'd come to expect between the tool I held, how I moved it, and what mark appeared on the paper or cloth. If I moved a brush in a fluid line, I saw a fluid line on the paper. With the computer, my bodily movements didn't

correlate with what appeared in the printout. I could watch the glowing screen, tap the keys, click and slide with the mouse, but what appeared on the paper could be lines, dots, color changes, images, or words. All the magic happened inside the box.

But I could never ignore magic for long. I realized that part of my resistance was because I felt that accepting technology into my creative life would force me to leave behind all the old tools and methods I loved. But technology is an option, like a brush in a rack. I can select to use it that day or walk away. To be an artist in this century, I didn't have to give up beautiful ink stones, stencil paper soaked in persimmon juice, or Chinese brushes. I could have them all.

I'll always enjoy the direct contact with nature, painting the back side of a butterfly wing, or smelling the sap as I flatten pine needles. But after I've made a nature print, technology can help me to reproduce the print or modify the design. Even the simplest possibilities intrigue me: pixelate, render, distort, solarize, emboss. In a way, I see the computer as another method of second sight. It shows me nature transformed and technologically touched. It may remove one kind of spirit, but adds another that I couldn't create without its participation. I feel like I'm collaborating with a presence that I've invented with the long brush of my mind.

And I think I've found another element that attracts me: The results feel mysteriously unfinished. Even my simple computer prints, with their slightly surrealistic colors, seem to be evolving into the future, their spirits not quite settled, their genre not yet jelled. I'm reminded of my brush's inscription:

"Your proper force can penetrate the paper." Finding the proper force and direction of any tool, old or new, brush or computer, has always been an artist's challenge.

My computer is ancient by today's standards. But I've decorated the beige plastic box with nature quotes, pictures of my butterflies, and a jade charm to ward off viruses, and I've even given it a name—The Old One, for the unending wisdom it holds. How can I replace it? After all, we do have our memories.

Variation of *Butterfly and Leaf Print.* Photoshop filter: Stylize and Emboss. 8 1/2 × 11 inches (22 × 28 cm).

NATURE PRINTS TO PRINTOUTS

Collaborating with a computer presents so many options that the hard part is choosing which ones to use.

What the Computer Offers

1. Reproduce your nature prints in their original designs and colors to sell or give to friends, or place the images on greeting cards, postcards, and business cards. If you wish, you can modify the brightness, contrast, and colors of your original.

 The size of your reproductions will be limited in size to the paper your printer can handle. Choose a good paper stock, such as premium glossy, semi-matte, or matte photo paper and print at the "Best Quality" setting. I recommend first using plain paper and "Draft Quality" until you are satisfied with the result. Also, using the paper the printer manufacturer recommends usually gives the best prints with the least amount of problems. Do keep in mind, though, that moving from plain paper to photo paper will change the printed result because of the differences in ink absorption and light reflection. And if you expect to sign and sell your prints as individual works of art, consider using archival inks to prevent fading and photo-quality paper so your prints will sustain their value over time.

2. Create variations of your original nature prints through image-editing techniques on all or part of your nature prints. It's a good idea to either remember to save your final variations on the software's "File Save As" command or take detailed notes so you can repeat your manipulations.

3. Make original prints by scanning actual leaves, rocks, twigs, bark, or flowers and then manipulating these images. You can also scan real objects to make templates for artwork or stencils for fabric designs. If you are going to use real objects, tape a sheet of clear acetate over the scanner's window to avoid damage to the glass and to prevent dust, moisture, and other unwanted materials from seeping through the gasket.

4. Print nature designs on fabric for quilts, wearables, T-shirts, and bags. You have four options for transferring your digital designs onto cloth:

 - INKJET PRINTER TRANSFER PAPER. This special paper sheet is placed in an inkjet printer and printed with the design you've created on the computer. Then the paper is ironed onto cotton or cotton/polyester fabric. When you peel off the paper backing, a washable and permanent design remains on the fabric.

 - INKJET PRINT-ON-SILK PAPER. Specially treated silk fabric is adhered to a paper backing, allowing the paper to run smoothly through most inkjet printers. The design printed on the silk must be steamed after printing; the manufacturer-provided instructions detail a simple steaming method using a deep metal pot and your kitchen stove.

- LAZERTRAN. Lazertran Silk creates an iron-on transfer for silk and other sheers and will not stiffen the fabrics. A computer design is copied in reverse or in mirror onto the shiny side of a sheet of Lazertran Silk with a color copier or toner-based laser printer. Next, lay a piece of silk over the design and iron until the silk sticks to the image. Place the design, paper-side down, into a bath of warm water until the backing paper falls off. Then lift the silk out of the water, place it facedown, and gently iron. When the silk is dry, turn it over and cover with a sheet of nonstick baking parchment. Iron over the image, allow to cool, and peel off the baking parchment. (Follow manufacturer's instructions.) Another product is Lazertran Transfer Paper, which allows you to transfer color images onto almost any surface by creating a type of decal that slides off the paper in water.

- BUBBLE JET SET 2000. With this product you can prepare just about any fabric for printing with inkjet or Bubble Jet printers. After saturating the fabric with the Bubble Jet Set solution, you allow the cloth to dry, iron it onto freezer paper (as a backing), cut it to the size of your printer, and print.

What You'll Need

As technology changes rapidly, detailed instructions are beyond the scope of this book. But the basic equipment you'll need to get started is a scanner, a computer, image-

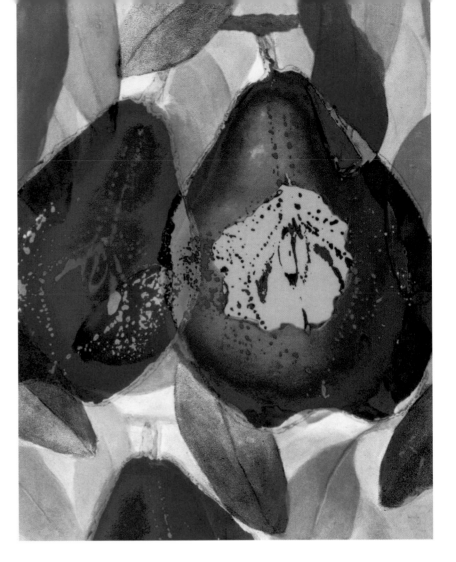

editing software (such as Photoshop), and a color printer. If you invest in a scanner, purchase one with a transparency unit for scanning slides and negatives as well as photos and real objects. If you don't wish to invest in a scanner, you can photograph your nature prints and have the photos scanned onto a Photo CD when developing the film. Or you can select specific photos after developing and then have a Photo CD made at a copy shop. With a good-quality digital camera, you can transfer your images directly into your computer.

Pared to the Heart, a digital print by Sue Liska. Sue scanned a pear print by Carolyn A. Dahl into Adobe Photoshop, layered it over a pear image from one of her own paintings, and adjusted the combined images using the Difference Blending and Transparency options. 8 1/2 × 11 inches (22 × 28 cm).

VARIATIONS: BUTTERFLIES AND LEAF PRINTS

Variations of *Butterfly and Leaf Print*. 8 1/2 × 11 inches (22 × 28 cm).

To make these images, I scanned a photograph of a section from the *Butterfly Quilt* (page 79) into an image-editing program (Adobe Photoshop). I then applied a variety of Photoshop's filter techniques before printing the images on Premium Plus Glossy Paper at "Best Quality" setting. Each variation redefines the beauty of the leaf print.

Photoshop filter: Pixelate and Crystallize.

Photoshop filter: Render and Lighting Effects.

Photoshop filter: Stylize and Glowing Edges.

Photoshop filter: Stylize and Solarize.

Fish

Fishing Outside Your Creative Boundaries

My father had a shaman's jewelry box
with magic feathered flies, silver shields,
and tiny painted fish. Their names,
recited slowly over the lake, cast
a necklace of spells over my imagination:
striper jigs, willow-leaf blades,
midnight ramblers, shad darts.

Rainbow Trout by Mineo Ryuka Yamamoto, made
with the indirect printing method. Oil on polyester.
27 1/2 × 39 1/2 inches (70 × 100 cm).

WHEN FISH FLY

As a child, I talked to fish. I believed that if I slipped my hand into the water and spoke, the sound would travel through my bones. The fish would respond by sending air bubbles to the surface with messages only I could understand.

Today, I sing to fish. An uncle once told me, "Fish like music. In Florida, you have to bang tambourines to entertain them, otherwise they ignore you." I had looked skeptical. He smiled and continued, "The biggest fish I ever caught came right up to my boat, waving its fins in time with a country-western tune."

My singing doesn't produce any fish, though, so when the ripples of my voice stop, I simply listen to the lake. Everything in nature has its own song, I remember once reading. Every body of water can be identified by the sound of its sand grains moving in the current. I'm content to listen for hours, imagining fish and ground-up mountains sloshing under my boat.

I want to meet fish . . .

run a finger down a perfect row of scales and wonder how it feels to slip through water in a skin of shiny armor.

Hanging over the boat's edge, I peer into the wet world. I search the weedy depths for any movement—a flash of tail, a glint of scales. Fishing isn't about food for me; I want to meet fish. When I catch one, I hold it in my lap, touch the needlelike points of its fins, run a finger down a perfect row of scales, and wonder how it feels to slip through water in a skin of shiny armor. I lift the fish to my eyes to know the expression it wears. Perhaps I want it to speak. Without eyelids, the fish never blinks, so I stare several minutes into its large, sparkling eyes. I know it's watching me. Researchers say that a fish may be able to see us on the water's surface, although in a distorted way. Perhaps as I look over the edge of the boat into the fish's world, it is staring back at me, silhouetted against the late afternoon sun.

Suddenly I hear a plop, then another. The fish are flying. They break the water's surface with mighty leaps, strain for the sky, glisten like wet glass, and drop back with a splash. I forget to breathe. These aren't true flying fish, of course, not like the Amazon hatchet fish that flap their fins like butterflies, or even like the gliders of California. These are jumpers, ordinary fish making magical moments. They aren't supposed to fly. Still, they leap into the unknown and cross the boundary between water and air.

They remind me that once in a while I need to jump out of my artistic bowl. Sometimes I'm like a tropical fish that grows to the size of its container, swimming in circles day after day. To make a creative leap, I have to surprise myself. The surprise could come from an unexpected happening like the appearance of flying fish, but it could also be something simple, like reading a fascinating or bizarre fact that amazes me. If I'm affected deeply without being able to explain why, if I pause and wonder, if the words won't release my mind, I pay attention. Something has attracted my creativity.

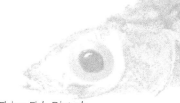

Sometimes, however, I'm pushed to break boundaries by my own work. If a section of a finished piece keeps drawing my eye and emits a certain energy, something new is growing there. It might be a color combination I've never used, an unusual shape, an accidental texture, or a technique that needs further development. Like a flying fish's tail that began to mutate so one side would be longer (acting like a motor as the body "lifted"), a germinal section of my work can indicate a coming change in artistic direction.

Of course, I can choose to follow a new path or ignore it. Fancy goldfish have huge, sail-like tails, but they don't leave their safe fish bowls to fly. I must want to leap into the unknown, risk losing what I have to acquire what might be. Developing the patience to explore and then knowing when it's time to fly makes turning fins into wings an act of courage.

Flying Fish Diptych by Heather Fortner. Oil-based lithographic ink with watercolor background on Rives BFK paper. 24 × 48 inches (61 × 123 cm). Photograph by Q Photo.

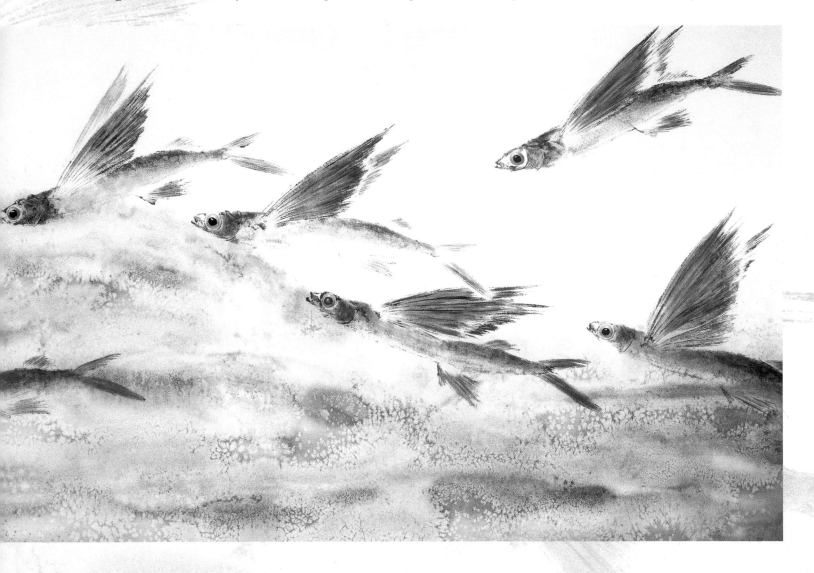

PRINTING FROM THE POND:
REAL FISH

Codfish by Mineo Ryuka Yamamoto, made with the indirect printing method. Oil on polyester. 35 1/2 × 59 inches (90 × 150 cm).

When making prints from real fish you can choose between two methods: the indirect method, in which the paper—not the fish—receives the paint, and the direct method, in which the fish is painted.

In the past, the Japanese word *Gyotaku* was reserved for the indirect method of fish printing favored by Asian artists. Gyotaku means fish rubbing (*gyo* = fish, *taku* = rubbing).

It is believed that the technique was introduced to Japan around 1855 by Catholic priests who went to China to study stone rubbing. Today, however, the term is more liberally used, and many fish prints are labeled Gyotaku whether they are done in the indirect or direct method.

In the indirect method, a thin paper or fabric is placed over a clean fish. A paint

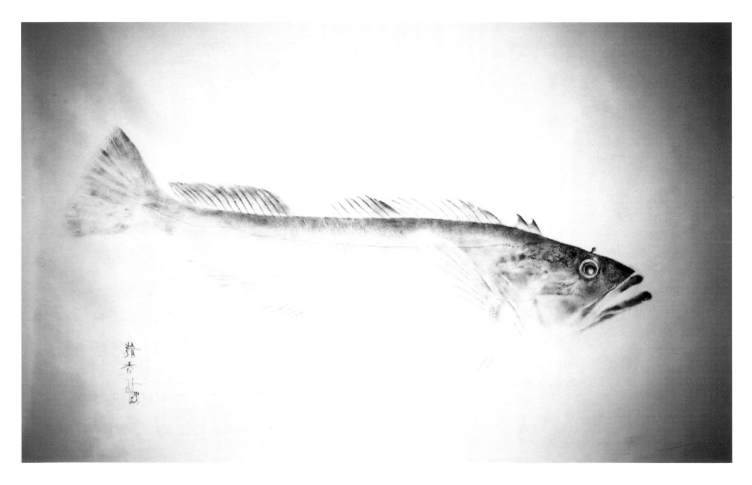

Trigger Fish by Lori Hatch, made with the direct printing method. Water-based block-printing inks and watercolor on Hosho Professional paper. 19 × 24 inches (48 × 61 cm). Photograph by Mark Bergsma.

applicator called a silk tampo (silk fabric filled with cotton, gathered, and bound with rubber bands; see page 101) is loaded with ink and gently tapped over the paper or fabric's surface. This method requires some practice. Its advantage is that, because the image develops on top of the paper like a rubbing, you are able to watch the delicate print progress scale by scale.

Many printers, however, favor the direct method of fish printing, as it yields bold prints with strong details. The paint is applied to the surface of a clean fish. Paper or fabric is placed over the painted fish and is then rubbed gently to transfer the paint from the fish to the underside of the paper. Only when the paper or fabric is removed from the fish

can the printer enjoy what has been secretly happening under her moving hands. It's always a surprise and adds mystery to the process.

THE HEADS AND TAILS OF FISH PRINTING

A wonderful way to honor the beauty of fish is to make a print from a real fish. Whether you're documenting your prize catch or making prints from a supermarket fish for your home, the process is a fascinating experience. If you prefer, however, not to work with a real fish, rubber fish replicas are also available. Molded from actual fish, they are very lifelike (see page 106). Special rubber stamps, whose images were made from an artist's fish prints, are another substitute for real fish (see page 108).

Selecting the Fish

In the superclass of Pisces there are approximately 25,000 known species, so you'll never want for variety in printing real fish. If you can't go fishing, check with your local fish market. Chain supermarkets seldom carry fish with scales anymore, but Asian and Hispanic stores have wonderful selections. Plan to shop the same day on which you want to print.

Don't be afraid to try any variety that appeals to you. Even squid, like those at left, have beautiful printable shapes. A good fish for a beginner is the flounder (opposite, top) because it lies flat and doesn't shift much during printing. Perch, rockfish (below), and bluegill have hard scales that stand slightly away from the body, giving the print a definite texture. Trout (opposite, bottom), carp, and salmon have delicate scales with a subtle texture yet elegant, long bodies, making them a favorite choice; some printers remove the scales completely and print the skin indentations (scale pockets) of these fish.

Whatever fish you purchase, make sure it is fresh and doesn't have damaged fins, cuts in the body, or loose or missing scales.

Before you leave the store, ask for a few fish bones; they make beautiful prints. You might even ask for a bag of scales. If you've ever looked at a scale under a microscope, you'll understand why many fish lovers start scale collections. Scales can be round, long, or barbed, and have rings (as trees do) that allow us to date the fish. Scientists can even analyze a scale's chemistry and match it to the river or lake where a fish grew up.

ABOVE: *Puget Sound Squid* by Heather Fortner, made with the direct printing method. Oil-based lithographic ink on Hosho and Sekishu paper. 10 × 18 inches (25 × 46 cm). Photograph by Light Inc.

RIGHT: *Rockfish with Maidenhair Fern* by Lori Hatch, made with the direct printing method. Water-based block-printing ink and watercolor on A.K. Toyama paper. 23 1/2 × 37 inches (60 × 94 cm). Photograph by Mark Bergsma.

Flat Fish with Ginkgo by Heather Fortner, made with the direct printing method. Oil-based lithographic ink on Tableau paper. 9 × 12 inches (23 × 30 cm). Photograph by Light Inc.

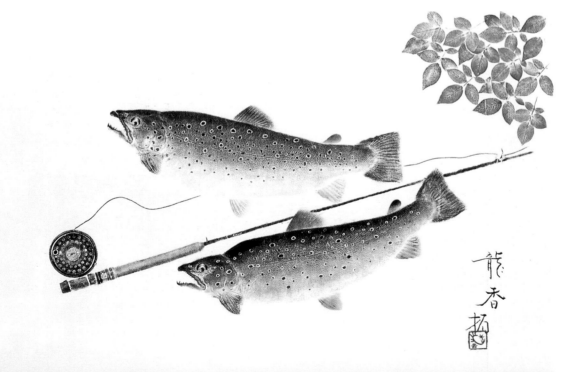

Brown Trout with Fishing Rod by Mineo Ryuka Yamamoto, made with the indirect printing method. Oil on polyester. 27 1/2 × 35 1/2 inches (70 × 90 cm).

99

Preparing the Fish

Before preparing the fish for indirect or direct printing, decide whether you want to print on paper or fabric (see pages 20 to 21). Many printers prefer fabric to paper when printing fish, especially very large ones: Fabric drapes around the body and doesn't shift as much during the time it takes to print a fish of substantial size. Do not dampen the fabric unless the ink refuses to penetrate the fibers.

Wash the fish very gently in soap and water to remove any mucous. Rinse well and blot dry repeatedly, lightly pressing on the fish to release any trapped water. Lay the dry fish on newspaper. Because the fish may have fluid in its intestinal tract that might leak out and stain your print, block the anus, gill, and nasal openings with either paper towels or a more permanent material like Super Glue.

Since the fish is a dimensional object, it needs to be stabilized so it won't rock while you print it. Lay it on clean paper and place supports (modeling clay, Styrofoam, folded paper towels, or cardboard) under the fins, the tail, and anywhere else necessary to keep the fish level and immobile. If the fins snap back against the body, spread them open and anchor them with a straight pin stuck into the support (place it inconspicuously between the ribs). You could also paint the back side of each fin with Super Glue and hold it open until it dries in the desired position. To keep the mouth slightly open, insert paper towels or a portion of a wood matchstick. Now you're ready to try either the indirect or direct method of printing.

To stabilize this red snapper for printing, modeling clay is inserted around the body, under the fins and tail. Super Glue has been painted on the back side of the fins and tail, which were held open until the glue dried.

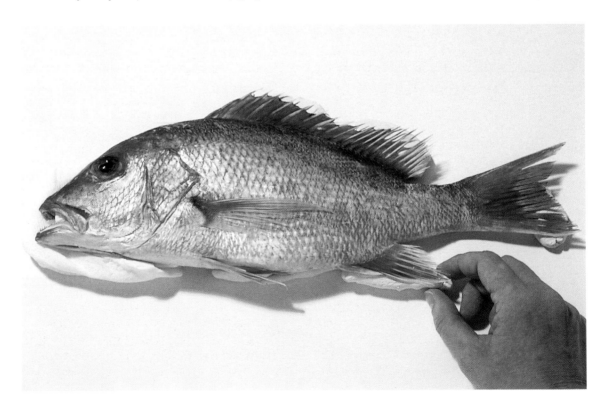

The Indirect Printing Method on Fabric

Remember, in the indirect method the fish isn't painted. In this demonstration, a polyester/cotton fabric is used, and water-based block-printing ink is applied to the top of the fabric by tapping gently with a tampo.

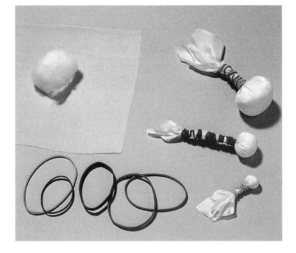

1 Make a large, medium, and small tampo, depending on the size of your fish. Work a piece of cotton into a smooth ball and lay it in the center of a square of China silk or Habotai (a 5-inch square of silk will yield a tampo surface of approximately ³/₄ to 1 inch). Gather excess silk into a handle, and smooth out any gathers that might affect the ball's surface. Wrap a rubber band around the handle from the base upward.

MATERIALS
- Cotton (or 3 to 4 cotton balls)
- China or Habotai silk (one of each: 5-inch, 4-inch, and 3-inch [13-cm, 10-cm, and 8-cm] square)
- Rubber bands
- Sulky KK 2000 Temporary Spray Adhesive
- Cleaned and stabilized fish
- Fabric (cut at least 6 inches [15 cm] larger than the fish on all sides)
- Circle of paper (cut large enough to cover fish eye)
- Hard rubber brayer
- Glass or Plexiglas palette (or freezer paper, shiny side up, taped to work surface)
- Black water-based block-printing ink
- Scrap paper
- Edge protectors (cut to the curves of the fish from blotter or stiff paper)
- Fine paintbrush

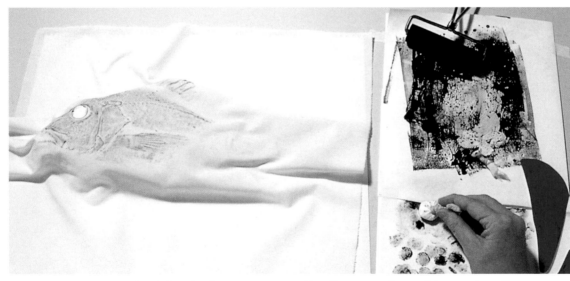

2 Spray the back side of the cloth with adhesive. (Any reversible adhesive may be used, but I prefer Sulky KK 2000 Temporary Spray Adhesive because it is made for fabric, has less odor, and is nontoxic, nonflammable, and ozone friendly. It disappears within two to five days without leaving a stain.) Lay the adhesive side of the fabric over the fish and press in place. Cover the eye with a circle of paper. (It doesn't print well and will be painted in later.) With the brayer, roll out the ink on the palette. Tap the medium- or large-size tampo into the ink, and then blot the tampo on a piece of scrap paper until it gives an even, light imprint.

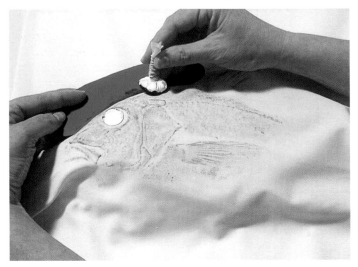 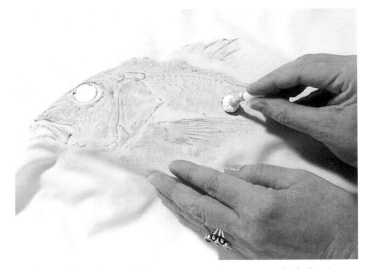

3 Hold the tampo near the top of the handle and apply the ink to the fabric with a gentle tapping motion. To keep ink within the fish's shape, use edge protectors.

4 The number of taps of the tampo—not the amount of ink that is on it—determines the darkness or lightness of the print. Use the small tampo for the mouth area. If you're working in multiple colors, make a different tampo for each. Remove the fabric and allow it to dry before you paint the eyes.

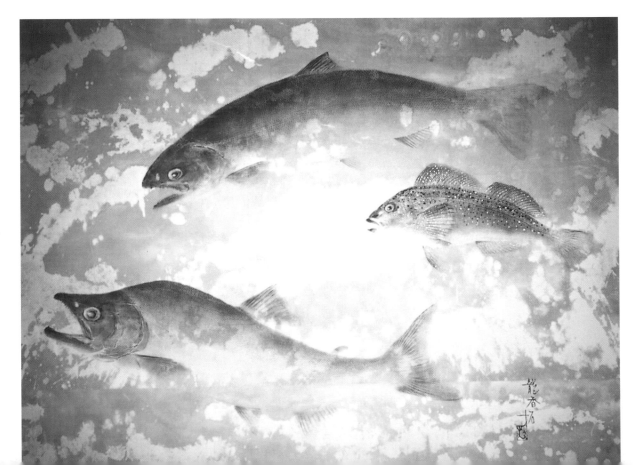

Cod and Salmon by Mineo Ryuka Yamamoto, made with the indirect printing method. Oil on polyester. 31½ × 43 inches (80 × 110 cm). Instead of the denser poly-cotton blend used in the demonstration, here a thinner, more slippery polyester was chosen, requiring a more controlled application of paint; also different is the artist's use of a paint that is oil-based.

Returning the Spirit: Painted Eyes

When the print is finished, the eye will appear as a blank circle. Painting the eye returns the spirit to the fish and gives life to the print. Study how artists depict fish eyes in illustrations such as fish encyclopedias. Look at your fish's eye closely. Then practice on scrap paper, using a fine paintbrush, to create a band of colored iris, a large black pupil, and a glint of white in the pupil to represent reflected light.

Oreo by Heather Fortner, made with the direct printing method. Oil-based lithographic ink on Iyo Glaze paper. 18 × 12 inches (46 × 30 cm). Photograph by Q Photo.

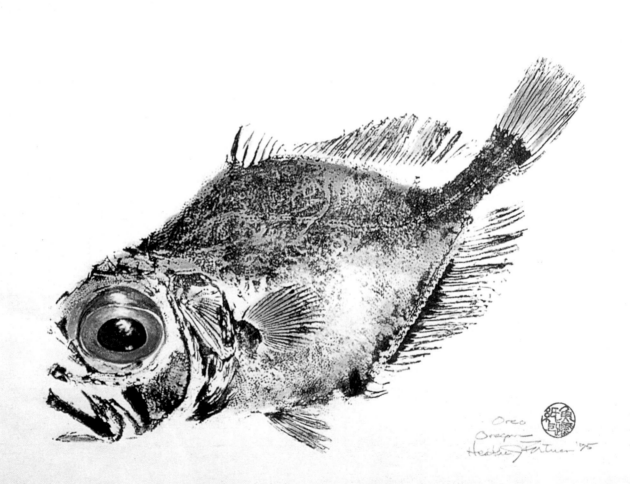

The Direct Printing Method on Paper or Fabric

MATERIALS

- ❏ Cleaned and stabilized fish
- ❏ Newspaper (torn into scrap pieces)
- ❏ Water-based block-printing ink (for paper) or fabric paints (for fabric)
- ❏ Foam rubber roller (or brushes, if you prefer)
- ❏ Glass or Plexiglas palette (or freezer paper, shiny side up, taped to work surface)
- ❏ Circle of paper (cut large enough to cover fish eye)
- ❏ Printing paper or fabric
- ❏ Fine paintbrush

The second method for printing from real fish is the direct method, in which the fish is painted. Except for preparing and stabilizing the fish, the process is the same as printing from fish replicas on paper, so refer to pages 106 through 107 for the demonstration photos.

If you'd like to print multiple fish images, refer to page 108, which explains the general concept of overlapping images. The one modification you'll need to make in the process is to spray adhesive on the back side of the fish print that serves as the mask. Otherwise, when you lift the paper or fabric and move it into position over the fish, the mask may slip off.

1. Once the fish is clean and stabilized, place paper scraps under the fins and tail and around the body to keep the surrounding surface free of paint. Brush or roll on the paint in the direction of the scales, then in

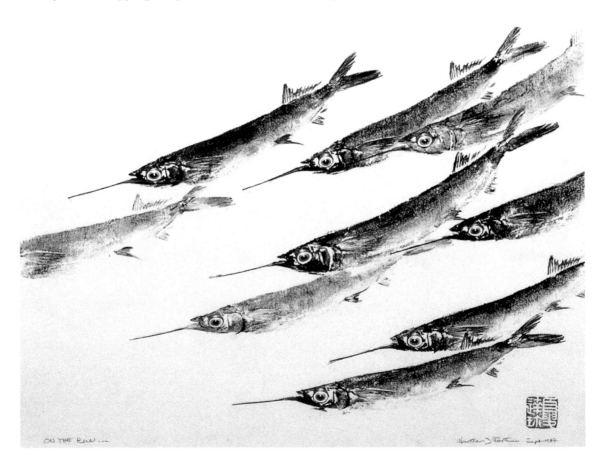

Ballyhoo-Half Beak by Heather Fortner, made with the direct printing method. Oil-based lithographic ink on Iyo Glaze paper. 17 × 22 inches (43 × 56 cm). Photograph by Light Inc.

the reverse direction. When painting the tail and fins, don't allow paint to collect in the webbing. Avoid painting over the eye (or cover with a circle of paper before printing).

2. Remove the paint-soiled paper scraps before printing to avoid picking up unwanted smudges on your paper or fabric.

3. Position paper or fabric over painted fish, allowing a little more space near the head than the tail. If you're using fabric, fold it in half, match the fold to the center of the fish's body, and then unfold completely to cover the fish.

 Hold the paper or fabric in place with one hand and rub with the other. Work either from the head to the tail or from the center of the body toward the edges, finishing with the fins and tail. Do not return to an area you have already rubbed. Enjoy the process, feeling under your fingers each scale, the streamlined shape of the body, and the edges of the fins and tail.

4. Starting at one end, slowly peel off the paper or fabric. Lay the print aside. Once it's dry, paint in the eye and enhance the print with watercolor or acrylic, if you like.

5. For additional prints, you can either repeat the procedure with the same color, paint a new color over the remains of the old one, or wash the fish to change the color completely. Don't forget to replace and remove the paper scraps each time you make another print. If after four to five prints the paint begins to build up and obscure details, wash the fish again.

 If you love the prints this fish makes, clean the fish and freeze it for future sessions. Many printers have kept wonderful specimens in their freezers for years.

King Salmon by Lori Hatch, made with the direct printing method. Oil-based block-printing ink, etching and lithographic inks on Rives BFK white paper. 25 × 32 inches (64 × 81 cm). Photograph by Mark Bergsma.

DEMONSTRATION

Printing without a Fish: Replicas

MATERIALS

- ❏ Fish replica
- ❏ Scrap paper
- ❏ Black and red water-based block-printing ink (for paper) or fabric paint (for fabric)
- ❏ Glass or Plexiglas palette (or freezer paper, shiny side up, taped to work surface)
- ❏ Foam roller (or brush)
- ❏ Printing paper or fabric (cut on all sides at least 6 inches [15 cm] larger than replica)

If you prefer to make fish prints without a real fish, rubber replicas are a good choice. The replicas come in a variety of species (plus a starfish, a snapping turtle, and a frog) and are anatomically correct because they were developed for use in science classrooms. They vary in length from 9 1/2 inches (24 cm) for the bluegill up to 13 1/2 inches (34 cm) for the flounder. They can be used for years, never have an odor, and are easy to clean and store.

The printing procedure is the same as printing with the direct method. Wash the replica before using it for the first time, as it has a slightly slick coating to keep the rubber soft in the package. If paint begins to dry on the replica while you're printing, spray the replica with water, blot it off, and begin again. When your printing session is over, wash the replica gently, using your fingers, a sponge, or a soft brush (not a toothbrush) to remove paint from the crevices.

RIGHT: If you prefer not to print from a real fish, prints can be made from fish replicas.

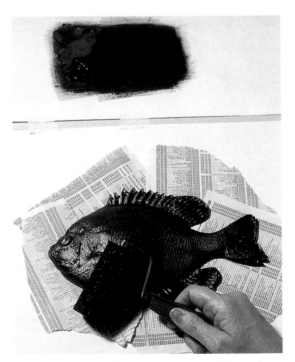

1 Place scrap paper just under the edge of the replica to keep the surrounding area clean. Roll printing ink onto the palette and smooth out any lumps. Begin rolling or brushing the ink onto the replica.

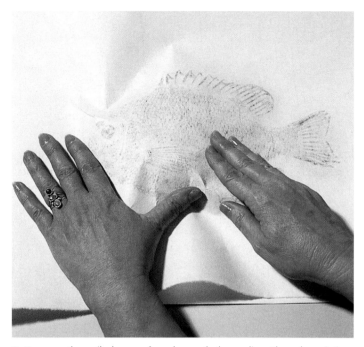

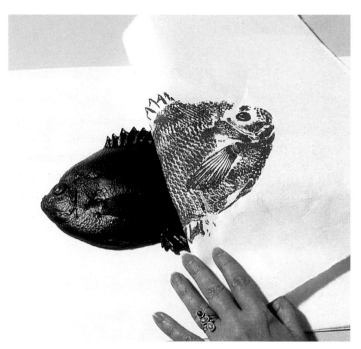

2 Remove the soiled paper from beneath the replica. Place the printing paper over the replica and rub with one hand while holding the paper in place with the other. The paint will transfer from the fish to the underside of the paper.

3 Remove the paper and allow the print to dry. Continue to make more prints by reinking the replica. Don't forget to place new paper scraps around the replica's edge each time.

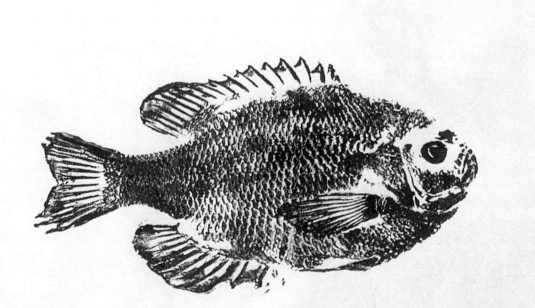

The finished print has a burgundy cast to the color because red and black inks were mixed. The replica will produce an eye print that can be painted, or covered with a sparkly stick-on hologram eye (available from WTP Inc. [see page 111] in both flat and dimensional molded versions).

Printing a School of Fish: Rubber Stamps

MATERIALS

- ❑ Fish rubber stamp
- ❑ Ink pad (with raised surface; select an ink for either paper or fabric)
- ❑ Paper or fabric (smooth surfaced, white or buff, sized to match your composition)
- ❑ Scrap paper
- ❑ Scissors

To make these special rubber stamps, the artist made a print from a real fish and then created a rubber-stamp image from the print. Thus, in using the stamps you're really stamping a fish print, not a drawing of a fish. The advantage of stamps is that the image is reproducible, unchangeable (no rubbing involved), and convenient. If you want to portray a school of fish, it's easy to use masks to create overlapping images because you see the work develop in front of you. This makes placement and registration easy. The size of these stamps also makes them versatile; some are as large as 3 × 8 inches (8 × 20 cm) and 3 3/4 × 6 3/4 inches (10 × 17 cm). I've used them on paper, fabric, walls, and many other surfaces.

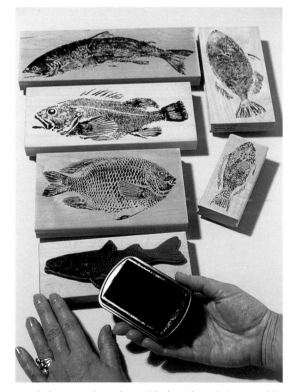

1 Ink the stamp's surface with the ink pad. (You could also use a roller to apply fabric paint to the stamp's surface.) Assortment of fish stamps available from Fred B. Mullett Co.

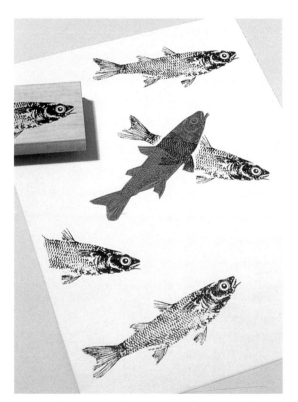

2 Press the stamp to the paper or fabric. To overlap fish, stamp the first print on paper or fabric, then make a second print on scrap paper. Cut out the scrap-paper fish and lay it over the dry first print as a mask. Then stamp the new fish over the mask.

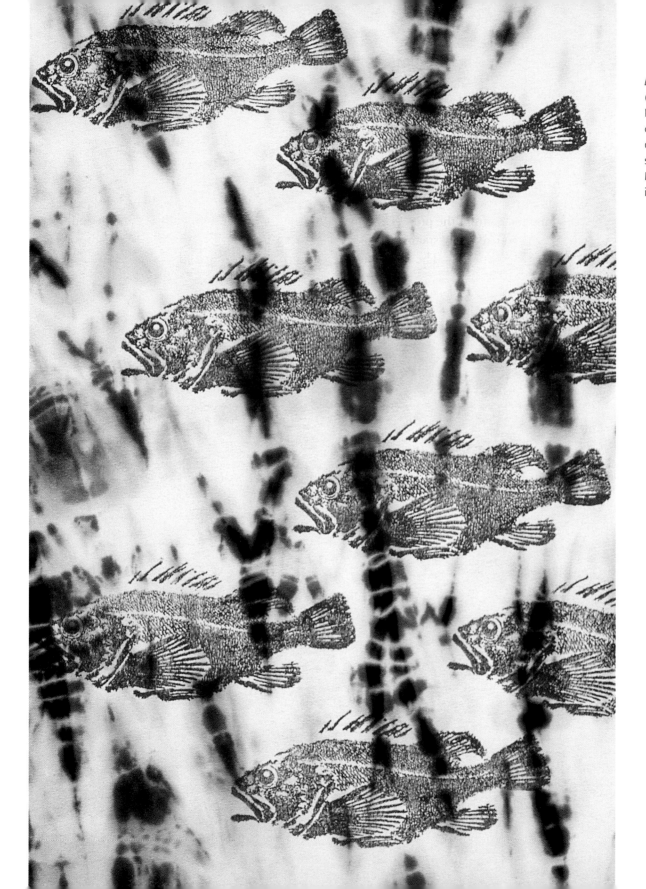

Big Rockfish Fabric (detail) by Carolyn A. Dahl. Fiber-reactive dyes and fabric paint on cotton. Big rockfish stamp from Fred B. Mullett Co. 36 × 36 inches (91 × 91 cm).

CLOSING

All nature prints depend
ultimately
on one print—
ours.

Let
it be
gentle.

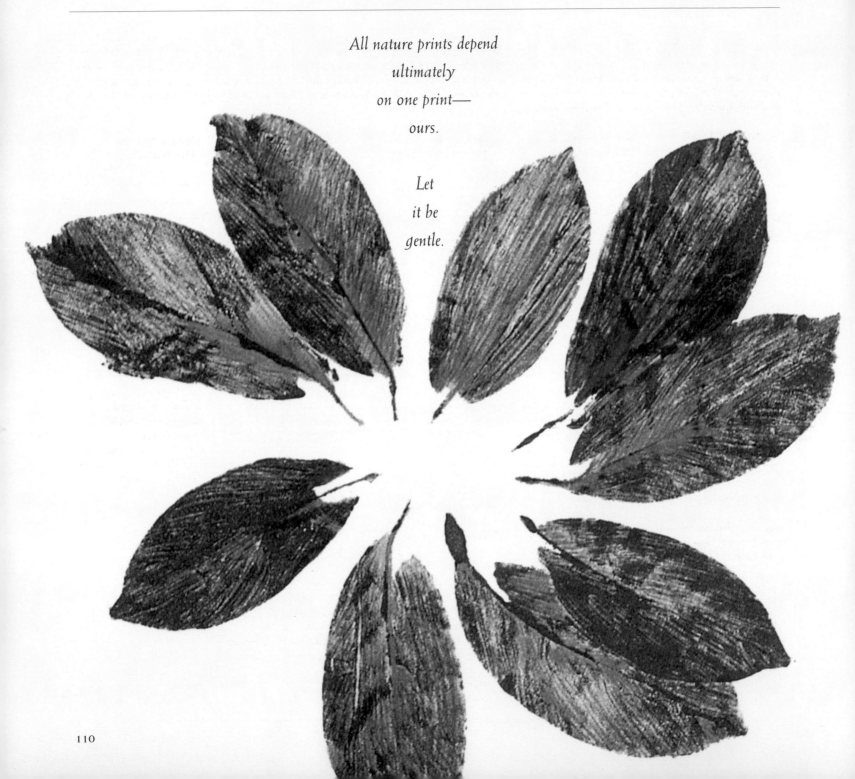

SOURCE DIRECTORY

Listed below are the manufacturers and suppliers for many of the materials used in this book. Most of these companies sell their products exclusively to art supply and crafts retailers, which are a consumer's most dependable sources for nature printing and art supplies. Your local retailer can advise you on purchases and can order a product for you if they don't have it in stock. If you can't find a store in your area that carries a particular item or will accept a request for an order, or if you need special assistance, a manufacturer can direct you to the retailer nearest you that carries their products and will try to answer any technical questions you might have. When purchasing hard-to-find or specialized materials, it's best to deal with specialized mail order and Internet sources.

MANUFACTURERS

Crayola Fabric Crayons
c/o Binney & Smith, Inc.
1100 Church Lane
P.O. Box 431
Easton, PA 18044-0431
(800) CRAYOLA
www.crayola.com
Heat-transfer fabric crayons

E.K. Success Ltd.
P.O. Box 1141
Clifton, NJ 07014-1141
(800) 524-1349
www.eksuccess.com
ZIG® textile markers; these have a brush and fine tip on each pen

Freudenberg Nonwovens
Pellon Division
20 Industrial Avenue
Chelmsford, MA 01824
Manufacturer of Wonder-Under® Transfer Web, available in fabric stores

Hero Arts Rubber Stamps
www.heroarts.com
Rubber stamps

Lazertran
650 8th Avenue
New Hyde Park, NY 11040
(800) 245-7547
www.lazertran.com
Lazertran Silk and Lazertran Transfer Paper

Rubber Stampede
2550 Pellissier Place
Whittier, CA 90601
(800) 423-4135
www.rubberstampede.com
Rubber stamps

Rupert, Gibbon and Spider, Inc.
P.O. Box 425
Healdsburg, CA 95448
(800) 442-0455
www.jacquardproducts.com
Lumiere, the best metallic paint

Sulky® of America
(800) 874-4115
www.sulky.com
Iron-on transfer pens and Sulky KK 2000 Temporary Spray Adhesive; call for referral to a retail store

MAIL ORDER SOURCES

Dharma Trading Co.
P.O. Box 150916
San Rafael, CA 94915
(800) 542-5227
www.dharmatrading.com
All brands of fabric paints and dyes; ready-to-dye clothing blanks and yardage in a variety of fabrics, including hemp; inkjet printer transfer paper, inkjet print-on-silk paper, Bubble Jet Set 2000

Fred B. Mullett Co.
Stamps from Nature Prints
P.O. Box 94502
Seattle, WA 98124
(206) 624-5723
www.fredbmullett.com
Fish rubber stamps

Matthias Paper Corp.
P.O. Box 130
Swedesboro, NJ 08085
(800) 523-7633
www.matthiaspaper.com
Tyvek®; 50-sheet minimum (rolls available on inquiry); ask for #1056-D

NASCO
901 Janesville Avenue
Fort Atkinson, WI 53538-0901
(920) 563-2446
(800) 558-9595
 (for orders)
www.nascofa.com
Butterfly larvae and food; life/form fish replicas

Pelle's See Thru Stamps
From Purrfection
12323 99th Avenue NE
Arlington, WA 98223
(800) 691-4293
(360) 691-4293
 (outside the U.S.)
www.purrfection.com
Rubber stamps

PRO Chemical and Dye
P.O. Box 14
Somerset, MA 02726
(800) 228-9393
www.prochemical.com
Anti-Chlor, fabric dyes and paints

Red Pearl Rubber Stamps
P.O. Box 94502
Seattle, WA 98124
Rubber stamps

Texas Art Supply
2001 Montrose Boulevard
Houston, TX 77006
(713) 526-5221
(800) 888-9278
www.texasart.com
Specialty printing papers and inks; LUTRADUR by the linear foot

Thai Silks
252 State Street
Los Altos, CA 94022
(800) 722-SILK
 (outside California)
(800) 221-SILK
 (in California)
www.thaisilks.com
Clothing blanks and yardage in every silk imaginable

WTP Inc.
P.O. Box 937
Coloma, MI 49038
(800) 521-0731
Hologram fish eyes

ORGANIZATIONS

Nature Printing Society
8821 Interlachen Road
Lake Shore, MN 56468
For membership information, contact Sonja Larsen: sonjanps@uslink.net

North American Butterfly Association
4 Delaware Road
Morristown, NJ 07960
www.naba.org
Membership organization that publishes a quarterly magazine and newsletter

INDEX